IMAGES
of America

BLACKSBURG

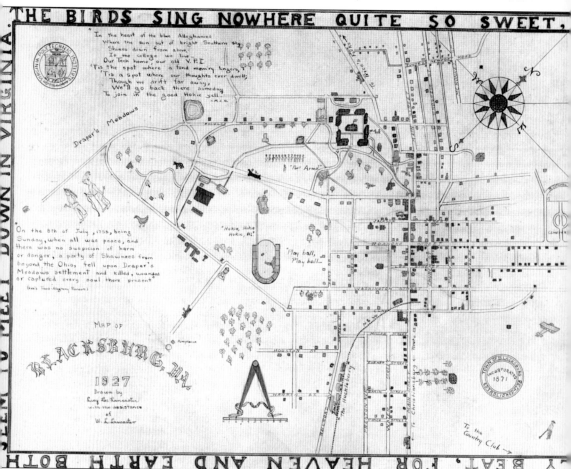

In the heart of the blue Alleghanies
Where the sun out of bright Southern sky,
Shines down from above.
To the college we love—
Our Tech home, our old V.P.I.
'Tis the spot where a fond mem'ry lingers,
'Tis a spot where our thoughts ever dwell;
Though we drift far away,
We'll go back there someday
To join in the good Hokie yell.
—M.E.W.

"Hokie, Hokie
Hokie, Hi!"

"Play ball,
Play ball."

"On the 8th of July, 1755, being
Sunday, when all was peace, and
there was no suspicion of harm
or danger, a party of Shawnees from
beyond the Ohio, fell upon Draper's
Meadows settlement and killed, wounded
or captured every soul there present"

MAP OF
BLACKSBURG, VA.
1927
Drawn by
Lucy Lee Lancaster
with the assistance
of
W. L. Lancaster

TOWN OF BLACKSBURG
INCORPORATED
1871

MAP OF BLACKSBURG. This is a 1927 map of Blacksburg drawn by Miss Lucy Lee Lancaster, who worked in the Virginia Polytechnic Institute (VPI) library at the time. The poem around the edges of the map reads, "The Birds Sing Nowhere Quite So Sweet, And Nowhere Hearts So Lightly Beat, For Heaven and Earth Both Seem to Meet, Down in Virginia."(DLA)

2

IMAGES
of America

BLACKSBURG

Richard Straw

ARCADIA

First published 2003
Reprinted 2004

Published by Arcadia Publishing
Charleston SC, Chicago IL, Portsmouth NH, San Francisco CA

Printed in Great Britain

Library of Congress Catalog Card Number: 2003107824

For all general information contact Arcadia Publishing at:
Telephone 843-853-2070
Fax 843-853-0044
E-mail sales@arcadiapublishing.com
For customer service and orders:
Toll-Free 1-888-313-2665

Visit us on the internet at http://www.arcadiapublishing.com

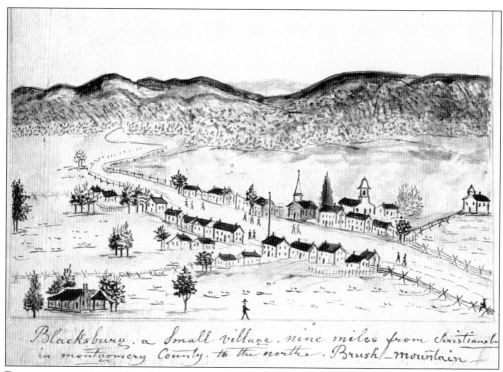

BLACKSBURG, 1853. This charming painting of the town of Blacksburg, nestled in the shadow of Brush Mountain, was done by folk artist Lewis Miller in 1853. While not completely accurate, it does contain several recognizable buildings from that time. (Used with permission of the Abby Aldrich Rockefeller Folk Art Museum, Colonial Williamsburg Foundation, Williamsburg, Virginia.)

CONTENTS

ACKNOWLEDGMENTS

In completing this photographic history of Blacksburg, I have had help from several sources. Three books were particularly useful in deciphering both the town's past and its built heritage: *A Special Place for 200 Years: A History of Blacksburg, Virginia*, Clara B. Cox, editor. Published by the Town of Blacksburg, Virginia, 1998; *A Survey of Historic Architecture in the Blacksburg Historic District, Montgomery County, Virginia*, by Gibson Worsham. Published by the MFRL Blacksburg Branch; and *Blacksburg: Understanding a Virginia Town: Town Architecture*, by Donna Dunay. Published by the College of Architecture and Urban Studies and the Extension Division, VPI&SU, 1986. In addition, a number of individuals offered help, suggestions, anecdotes, commentary, and sage advice along the way. The staff of the Special Collections division of the Virginia Tech library was accommodating and most helpful. I owe a particular debt of gratitude to Jane Wills. She was extraordinarily cooperative and patient with all of my requests for pictures and I could not have completed this book on schedule without her assistance. John Kline, owner of Gentry Photography Studio in downtown Blacksburg, was very generous in allowing me to look through his large collection of historic photographs. I want to thank him for his support of this project. I would also like to thank several other people in town for their enthusiasm and assistance. In any small town, there is a network of longtime residents who are particularly knowledgeable and passionate about their town's past. Through the kindness of my neighbor, Phyllis Hutton, I was put into contact with an important part of Blacksburg's history. She introduced me to Phyllis Blevins who in turn put me in contact with Annie Mae Albert, Dorothy H. Bodell, and Mary Elizabeth Lindon. I want to express my deepest and most heartfelt thanks to them all for giving me their time and for sharing with me their rich knowledge and stories about this wonderful place we call home. Thanks to Kelle Broome at Arcadia Publishing for her assistance and encouragement. Finally, I would like to thank my wife and children for their great interest and support and for putting up with all the photos I spread out on our living room floor. I especially want to thank my wife Jeanie for working so hard on the editing of the manuscript while I was in Scotland. I simply could not have finished this book without her good advice and hard work. Throughout the text, the following abbreviations appear after picture captions identify the photographic sources: (AP), the author's photos; (DLA), Digital Library and Archives, University Libraries, Local History and Temple Collections, Virginia Polytechnic Institute and State University; and (JC), the private collection of John Kline.

INTRODUCTION

On Saturdays, in the fall of the year, as leaves in the Blue Ridge Mountains of southwestern Virginia turn to soft browns, yellows, and reds, 60,000 fans gather to carry out football rituals in Lane Stadium on the campus of Virginia Tech. From the top rows, panoramic views of Blacksburg and the surrounding area are spectacular. Within site is Drapers Meadow, a broad flat plain that has attracted human settlement for thousands of years. In the mid-1700s, European settlers established a community there on a well-drained and well-watered plain above and a few miles east of the New River. In about 1745, John Patton acquired a large tract of land, known as Drapers Meadow, which lay between Toms Creek and the shadow of Price's Mountain. In 1773, William Preston bought several hundred acres of that land and moved his family to a house he built the next year. It was named Smithfield. Smithfield Plantation, within earshot of the stadium, is restored and open to the public and looks out today over this one-time frontier outpost.

While both Preston and Patton were important figures in the town's early history, Blacksburg's namesake is William Black, who moved onto the Drapers Meadow settlement in 1793. Black and his brother John inherited portions of the original Patton Tract from their father and in 1797 William Black donated nearly 40 acres of his land to begin a small village. In 1798, the 16-square-block town was officially sanctioned by the state legislature and established as Blacksburg.

Blacksburg grew slowly through its first 50 years. There does not seem to be a period in its history when its population was ever shrinking. The 1850 census reports that there were 270 whites and 63 slaves living in the village. In 1854, Blacksburg's Methodists founded a liberal arts school for young men called the Preston and Olin Institute and they erected an impressive building that would overlook much of the town. The town was largely unscathed by the Civil War and Blacksburg actually experienced a period of significant growth in the 1870s. In 1871, there were three churches, three hotels, a pottery, two tanyards, and numerous other stores and workshops of various kinds. In 1872, in a move that would forever alter the nature of the community, the town won the bid to be the site for a new land grant institution called the Virginia Agricultural and Mechanical College which, of course, has evolved into Virginia Tech. In 1875, in response to the college's new buildings and growing student population, the route that Main Street took through town was changed and the intersection of College Avenue and Main Street in front of the new college's main building became the town's focal point. It has remained so from that time.

The 20th century was witness to both great growth in the town and great change. In 1900, the town's population was approximately 800. While in 2000, the population was just shy of 40,000. The town secured a telegraph line as early as 1874 it gained access to railroad transportation only in 1904. In 2003, over 90 percent of Blacksburg's citizens have access to the Internet. During the decades following World War II, Blacksburg experienced all of the expansion and innovations associated with this era in American history. New business opportunities, new home construction, and new transportation routes all converged to initiate a period of rapid development that has dominated Blacksburg for the past 50 years. By the 1880s, Blacksburg was not only a town of professors but it was also a place of tinsmiths and carriage makers, tanners, blacksmiths, and store keepers. This dual character of the town has persisted through the 20th century. Although, today, in the beginning of the 21st century, Blacksburg's working class past has substantially given way to a population that is comprised by a larger and larger percentage of students, professors, researchers, and other highly educated and well-paid professionals.

This book contains over 200 photographs that document the life of this place. In its creation, an attempt was made to select photographs that give a valid overview of the town from the 1870s on. Photos were chosen that show the people, places, and events that shaped the town's life. There are many images of the way Main Street looked from about 1875 to the 1970s; the hotels, cafés, churches, schools, railroads, cars, homes, businesses, and of course the people, both prominent and ordinary, are featured. Blacksburg's history is intimately connected to that of Virginia Tech's and many photographs illustrate the close relationship the town has always had with this university.

Blacksburg is a diverse and articulate community that gains a substantial portion of its character from charming contrasts. Twenty-first century technology research laboratories coexist, within minutes by bicycle or car, with that of fresh fields of new mown hay or cows, grazing in pastures just off Palmer Drive within site of downtown. The individual photographs in this book show us what was here in the past. A collection of photos such as these reveals much of what is no longer here and what has changed over time. From looking at these photos, it is clear that much has changed in Blacksburg over 125 years that these photos document.

In 1998, Blacksburg celebrated its bicentennial. This celebration stimulated interest in the community's past and that attentiveness continues. In 2002, the town purchased the 1892 William Black House. Plans are underway to restore this magnificent home to its original grandeur and to use it as a community cultural center and town history museum. This and the recent restoration of the Lyric Theater, a downtown landmark since the 1930s, are strong indications of the critical commitment this community has to both its past and its future. The photos collected in this book add to the sense of pride that permeates these and other projects and aid in the understanding and appreciation of the town's past as it moves progressively into the future.

One

WELCOME TO
BLACKSBURG

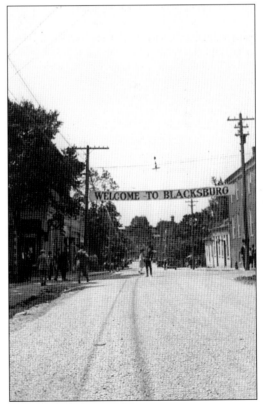

WELCOME TO BLACKSBURG. This is a view of Main Street looking north from the corner of Roanoke and Main Streets. The prominent building on the left, built c. 1920, was the original Bank of Blacksburg building. It now is home to Capones Jewelry. This photo was taken during the May 27–31, 1922 Golden Jubilee Celebration. The festival celebrated the founding of Virginia Tech in 1872. It looks as though in 1922 Main Street was not yet paved. (DLA.)

DOWNTOWN, C. 1880. The Main Street buildings pictured here would mostly disappear over the decades as would the first building (used by the new land grant university) that would become Virginia Tech. Olin Hall is pictured in the center of this photo on the hill. Built in 1854 for the Olin and Preston Institute, it was founded as a Methodist liberal arts school. Main Street itself was reconfigured in 1874 to connect to College Avenue directly in front of Olin Hall. (DLA.)

MAIN STREET SCENE. Another view of Main Street looks north toward Olin Hall. Although no date is available for this photo, it is clear that it is from the late 19th century. (DLA.)

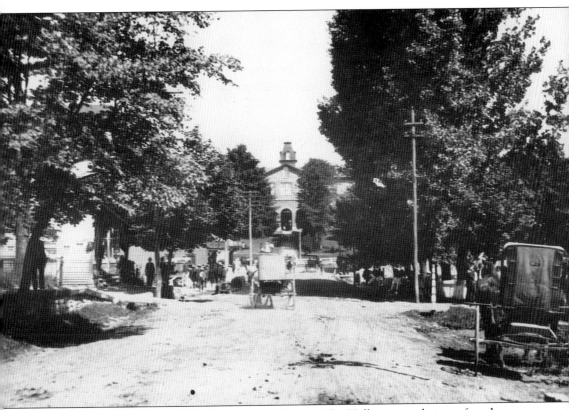

OLD SHOPS BUILDING, 1904. By 1904, what had been Olin Hall was now being referred to as the Old Shops Building. In this photograph, the people seem to be heading towards the intersection of Main Street and College Avenue, possibly for a special event. (DLA.)

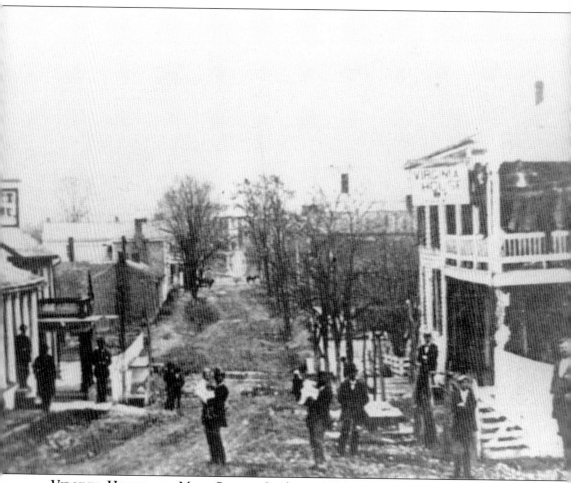

VIRGINIA HOUSE AND MAIN STREET. In this *c.* 1900 view up Main Street looking north towards the campus, quite a few people are seen posing in the street for the photographer. The Virginia House hotel is on the right. At one time—in the early 20th century—there were at least three hotels on Main Street. (DLA.)

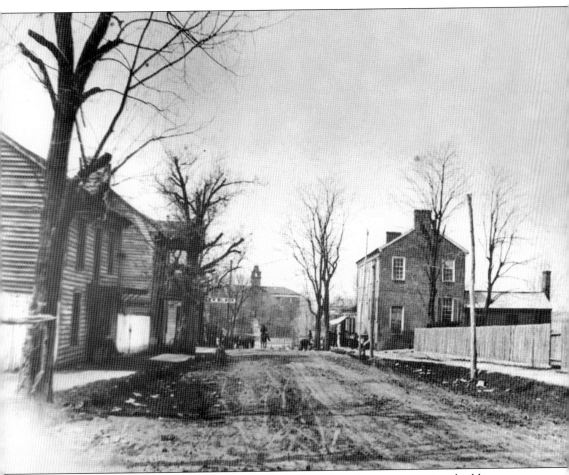

DOWNTOWN IN 1900. Looking north towards College Avenue two important buildings are visible. The prominent two-story building, with porches, on the left is the town's first bank building, built in 1855. The office of businessman Alex Black, the bank's first president, can be seen beyond it. The brick building to the right is possibly the oldest brick structure in the town and housed a variety of businesses over the years. (DLA.)

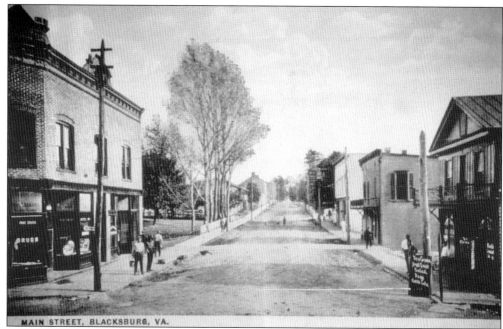

MAIN STREET, BLACKSBURG, VA.

LOOKING SOUTH ON MAIN. These are beautifully photographed views of Main Street looking south from what is today the corner of College Avenue and Main Street. The Ellett Drug Store and the U.S. Post Office are located in the prominent brick building on the left. It was built in 1900 and survives today. From these early photos, it is obvious how much Main Street has changed. On the right of the photographs one can see Sarvay's Store on the corner, next is the building which currently houses Joe's Diner, and farther up the street is the Hardwick Building, which over the years was occupied by various businesses. (DLA.)

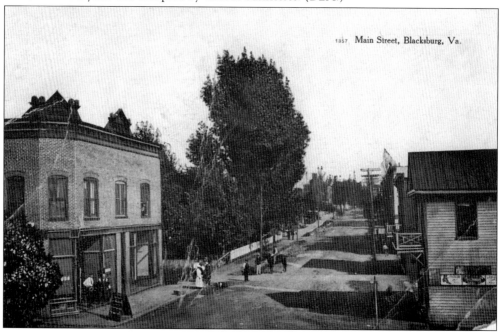

1357 Main Street, Blacksburg, Va.

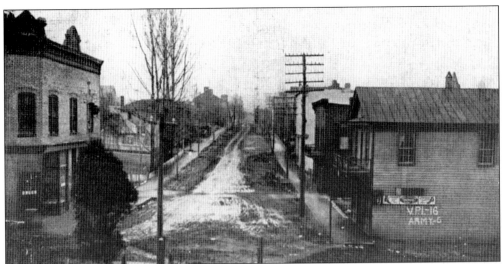

VPI 16, ARMY 6. This is a photograph from the early 1900s looking south on Main Street from College Avenue. This photograph is unique to the collection in that there are no people. Either the photo was taken in the very early morning or everyone was out celebrating the VPI victory over Army! In this photo, you can see that Blacksburg's downtown was wired very early for electricity—a remarkable achievement for a town so small in this time period. (DLA.)

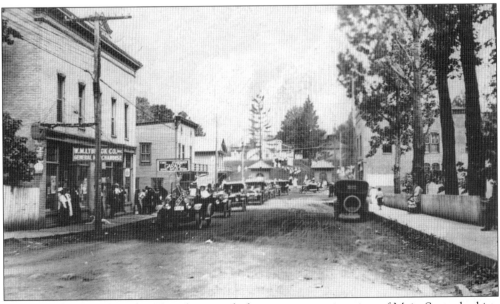

PARADE ON MAIN STREET. This photograph demonstrates a nice view of Main Street looking north with the Alumni Gate visible in the background. The W.M. Lybrook General Merchandise store is on the left in the photo in the brick Hardwick Building. The parade in the photo is unidentified but it could have been in conjunction with the 50th anniversary of marking the end of the Civil War in 1915. (JC.)

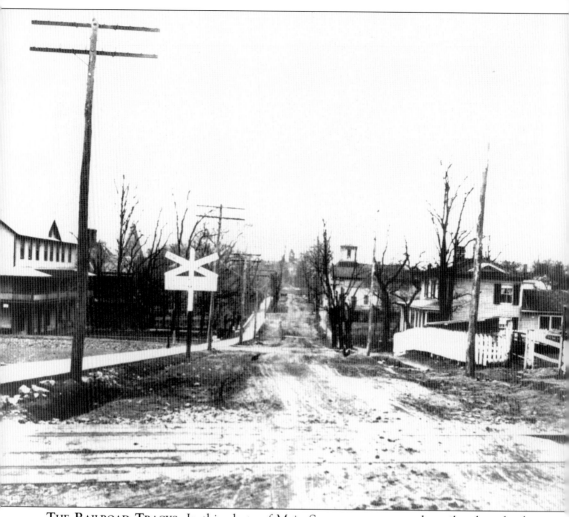

THE RAILROAD TRACKS. In this photo of Main Street, one can see the railroad tracks that crossed over the street after the new N&W Station was built on the site of the current Town Hall around 1912. The tracks terminated at the Blacksburg Lumber Yard on Main Street. At this time, the portion of Main Street shown here was primarily residential. The church at 117 South Main can be seen on the right of the photo. (DLA.)

MAIN STREET, 1925. By the mid-1920s Main Street had changed considerably from the first decade of the 20th century. There are, of course, many more automobiles on the street and parking seems to have been at a premium even then. Notice the addition of the early free-standing traffic signal in the middle of the intersection. (DLA.)

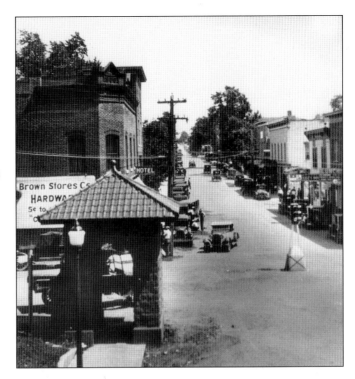

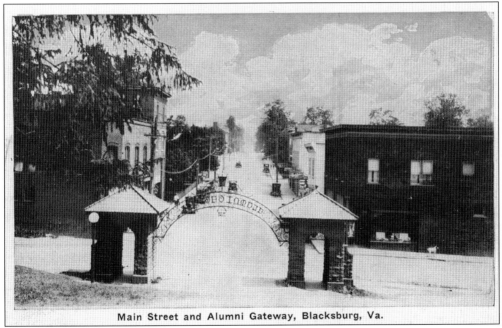

Main Street and Alumni Gateway, Blacksburg, Va.

ALUMNI GATEWAY. This impressive structure graced the entrance into the VPI campus from the corner of Main and College Streets in the early decades of the 20th century. A new, more substantial brick building now sits on the west corner where Sarvay's Store stood for many years. This is the brick building that still stands and is known by many longtime residents as the Corner Drug building although that business is no longer there. (DLA)

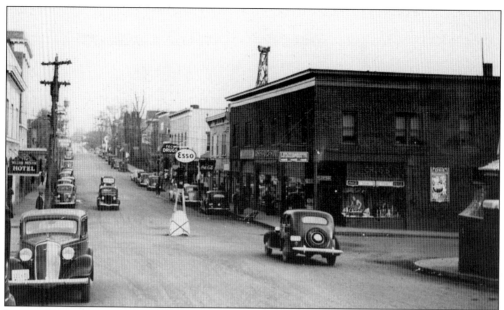

IN THE HEART OF TOWN. This is a wonderfully detailed view of the very heart of Blacksburg's commercial center in the 1930s. This is a familiar scene even today and all of the buildings seen here still stand with the exception of the Colonial Hotel building on the right side of the street. It is the building with the extended porch beyond the Tech Drug sign. The movie poster on the side of the drug store on the corner advertises a show at the Lyric, which opened up in its present location, around this time period. Main Street in this photo does not yet appear to be paved. (DLA)

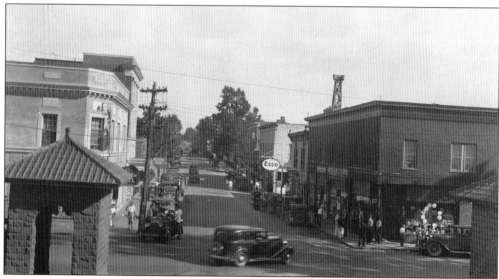

A BUSY DAY. This is a slightly earlier photo than the one above which shows an identical scene. On the right hand side of the street, beside the brick Roses building is the old building which at this time housed the Varsity Grill, to be renamed the College Inn in 1929. Following a fire in 1923, the building, which had previously housed a barber shop and a bank, was substantially remodeled. The interior of the restaurant that is in this building today is largely unchanged from what it looked like in the late 1920s. (DLA)

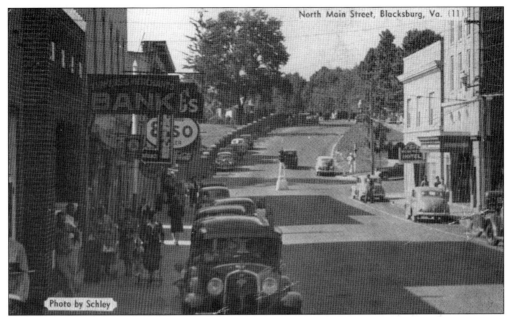

NORTH MAIN STREET. In this postcard photo, looking up North Main Street across College Avenue, the present configuration of Main Street and the entrance to Virginia Tech can be seen. In 1938, the old gateway was removed and Main Street was redirected straight up the hill where Olin Hall had stood until 1913. (JC.)

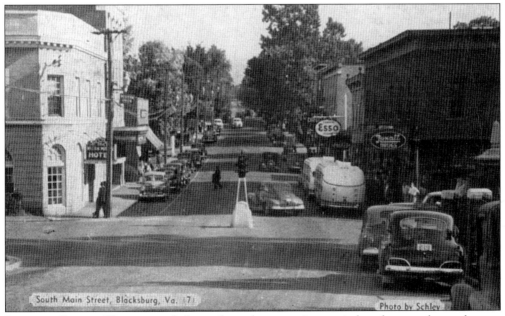

LOOKING SOUTH. This postcard photo, from the same time period as the one above, shows a view down South Main Street. Notice (left) the new facing on the Ellett Building and substantial altering that had occurred in order to house the William Preston Hotel. The old traffic light still remains but new buildings have gone up on the street and Main Street has lost the residential character it had in the earlier times. (JC.)

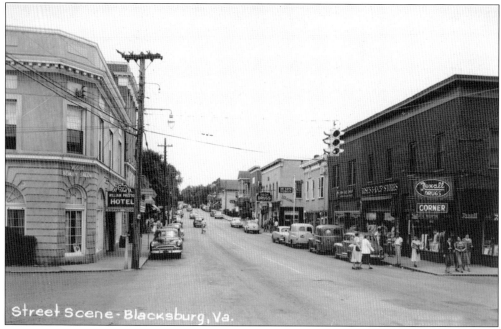

STREET SCENE, 1950. Many fascinating details of life in downtown Blacksburg are evident in this photo. Two drug stores, an auto dealership, a café, and two hotels are all within a block of each other. Clearly seen in this photo is the double-porched Colonial Hotel, a downtown landmark that would eventually be torn down to make way for a new building. For many years, the new structure was occupied by the Grand Piano and Furniture Store. (DLA.)

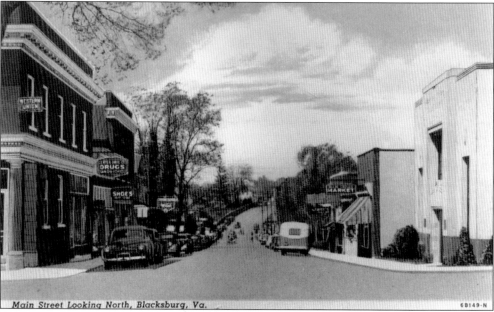

POSTCARD, 1950s. Looking north on Main Street, this time from the corner of Roanoke Streets and Main, another view of downtown can be seen in this photograph. On the left is the original Bank of Blacksburg building and on the right is the new Bank of Blacksburg building, built in the 1940s. (JC.)

20

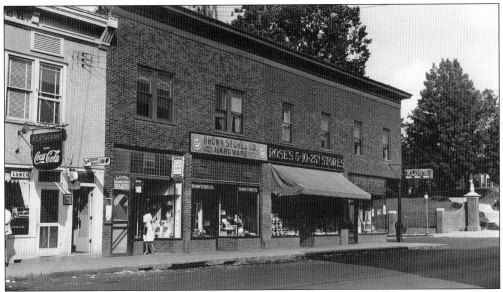

THE COLLEGE INN. In this photo from the 1950s, one of the oldest structures still standing on Main Street is seen. The building here which holds the lunch counter and the beauty shop was once a wooden structure that housed one of the town's first banks. It was remodeled after the fire in 1923 and has had a restaurant in it for nearly all of the years since then. The new entrance to Virginia Tech which was built in the late 1930s can be seen in this photograph. (DLA.)

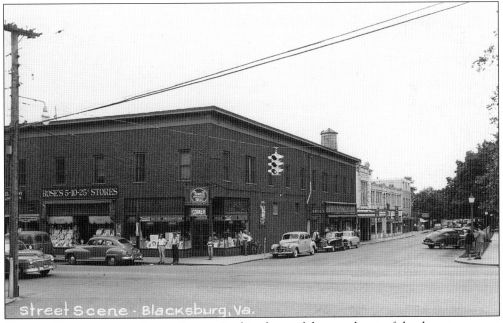

CORNER DRUG AND THE LYRIC BLOCK. In this photo of the very heart of the downtown, one can see Rose's, the Corner Drug, and the whole block built in the early 1930s to support the new location of the Lyric Theater. Street lights and a raised traffic signal give this photo a modern look. Notice the diagonal parking on College Avenue, a feature popular in many town's at this time. (DLA.)

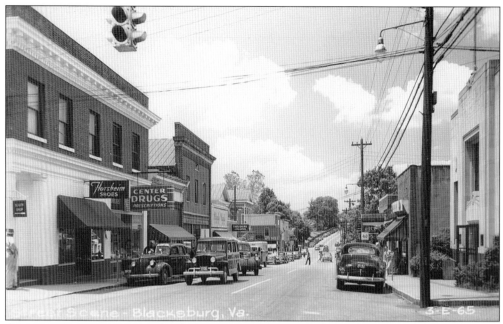

ANOTHER LOOK. Here is another look up North Main Street from the corner of Roanoke Street about 1950. The bank building on the left has a new exterior look. (DLA.)

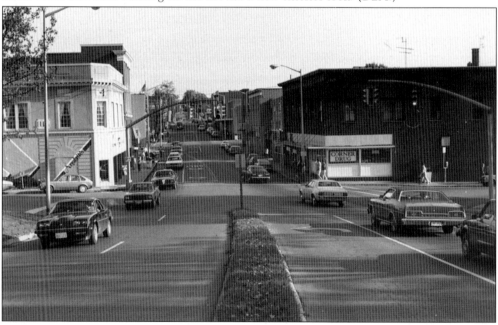

MODERNIZED. Much had changed in the physical appearance of downtown Blacksburg by the 1970s, a fact that can clearly be seen from the vantage point of this photo. Store fronts had been altered and both the Colonial Hotel and the William Preston Hotel were gone. While many small towns lost much of their commercial identity in the 1960s and 1970s, Blacksburg managed to hold at least for a time. As late as 1966, Blacksburg's downtown had four grocery stores, two hardware stores, a department store, two drug stores, and a five and dime store. (DLA.)

Two

AROUND TOWN

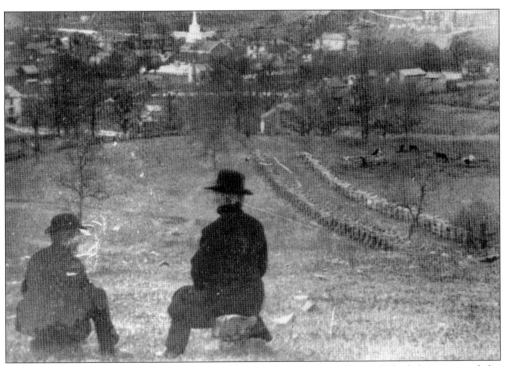

A VIEW OF THE VILLAGE. This is a lovely look at the pastoral village of Blacksburg around the year 1888. One can only imagine the excuse that these two men found to stop and rest at such a picturesque site or even their topic of conversation. Nevertheless, the photographer captured both them and the town in a splendid moment of repose. Buildings of the new Virginia Agricultural and Mechanical College are visible in the far background of the shot. The white church steeple in the center of the picture is the Blacksburg Methodist Church, built in 1846. In the 1880s, one of the main turnpikes leading into town came through Ellett Valley roughly where Lee Street is currently situated. It is possible that this road is pictured on the right in the photo. (DLA.)

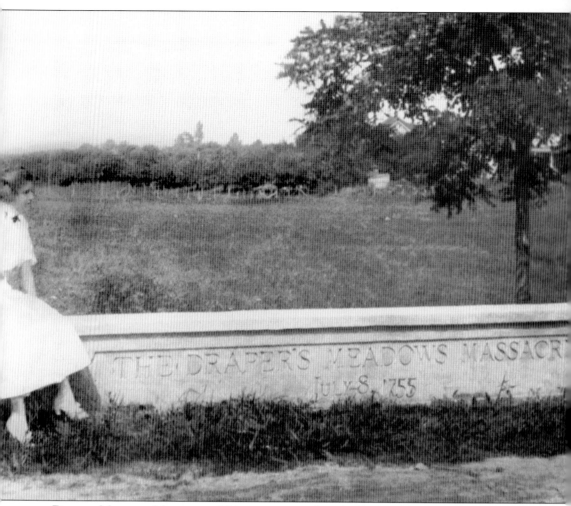

DRAPER MEADOW MASSACRE. This is a memorial to the Draper Meadow massacre of July 8, 1755 constructed on the VPI campus near the present site of the Duck Pond. This monument, once part of a road that ran through campus, is still standing but is barely noticeable today. The monument was built to commemorate the Shawnee attack on the Drapers Meadow settlement near this area. The attack resulted in the death of Colonel Patton and others as well as the kidnapping of Mary Draper Ingles and members of her family. There is some debate about the exact location of the settlement from which they were taken. Some believe it was on the site close to this memorial while others believe that the settlement lay outside the present town limits somewhere between Blacksburg and the Prices' Fork community. (DLA.)

ELLETT VALLEY, 1934. Stretching out between Blacksburg and Catawba to the northeast, Ellett Valley is the epitome of the rural, agricultural world from which Blacksburg emerged in the late 18th century and continued to share during the 19th and even 20th centuries. Today, Ellett Valley retains much of its rural flavor but it has also had to make room for several housing developments. These developments dot the hillsides as Blacksburg's population has spilled over into Montgomery County. (DLA.)

THE WIDE VALLEY. This is another view of the extraordinary beauty that surrounds Blacksburg and lends a special quality to its character and lifestyles. (DLA.)

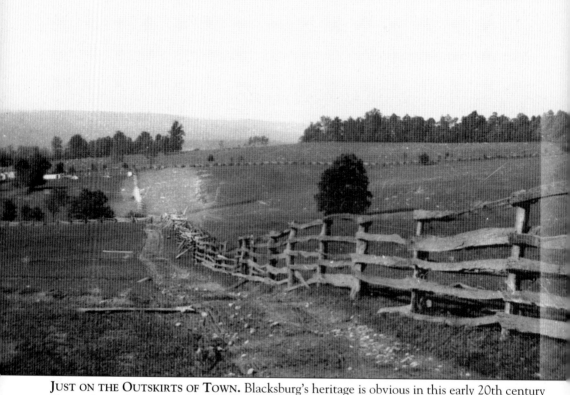

Just on the Outskirts of Town. Blacksburg's heritage is obvious in this early 20th century photo of a rural scene on the edge of town. The area where Blacksburg was laid out in 1798 was settled and lived in as early as the 1740s. The village was slow to grow throughout the 19th century but its growth was steady throughout its more than 200 year history. While Blacksburg in the early 21st century is a sophisticated mecca of academic and technological expertise, its citizens continue to value, guard, and preserve its natural setting and pastoral landscapes for future generations. (DLA)

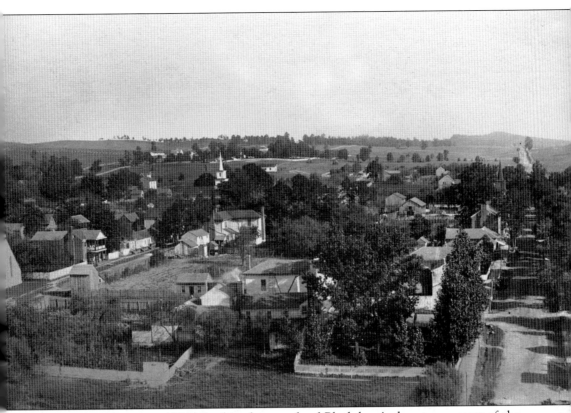

VIEW OF THE TOWN IN 1908. In this photograph of Blacksburg's downtown, most of the town's early buildings are recognizable. On the left side of the photo is the Episcopal church, which was built on the corner of Church and Jackson Streets in 1879 where it still stands. Up Church Street is the large Lybrook home and beside it the row of rental quarters known as Lybrook Row. The Methodist church steeple is clearly visible in the center of the photo with the Amiss-Palmer home known as Mountain View perched on the hill behind the steeple surrounded by the white fencing. On the right in the photo is Main Street, looking south. The Presbyterian church steeple at 117 South Main can be seen. The large white building in the center foreground of the photo is the Blacksburg Hotel, part of which dates to 1850. VAMC students who lived in Lybrook Row ate at the hotel during the mid-1870s. This building was also known through the years as the Western Hotel, George Keister's house, and the Roop House. It was torn down in the 1950s. (JC.)

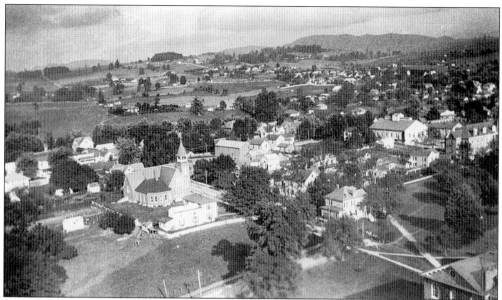

THE NORTH END OF TOWN. This is a rather rare view of the north end of town showing Main Street and some side streets from around 1908. VPI buildings can be seen on the right hand side of the photo. The church in the center of the photo is the Luther Memorial Lutheran Church, which used to sit on what is today Turner Street. (DLA.)

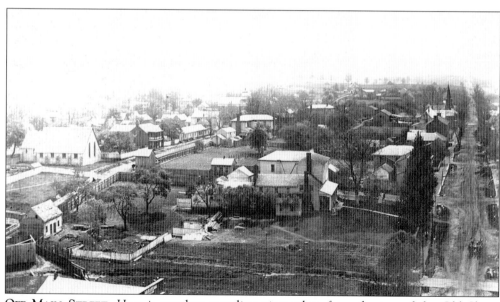

OFF MAIN STREET. Here is another revealing view taken from the top of the Old Shops Building on the university campus about 1908. This photo clearly shows us the Blacksburg Hotel, the Episcopal Church, Lybrook's house and rentals and Main Street. Most properties were surrounded by fences because many people kept livestock in town. (DLA.)

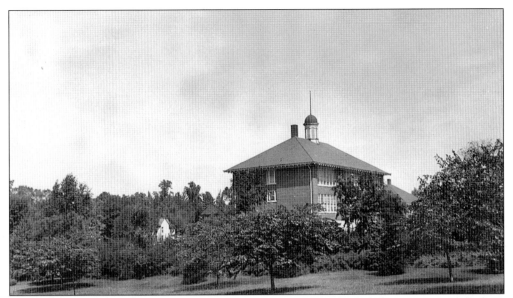

BLACKSBURG HIGH SCHOOL, 1942. In 1916, the town of Blacksburg constructed these buildings to serve as the high school. This was in response to laws that had been passed in 1906 by the Virginia General Assembly which promoted such activity. These buildings still stand between Draper Road and Otey Street but are now owned by Virginia Tech. (DLA.)

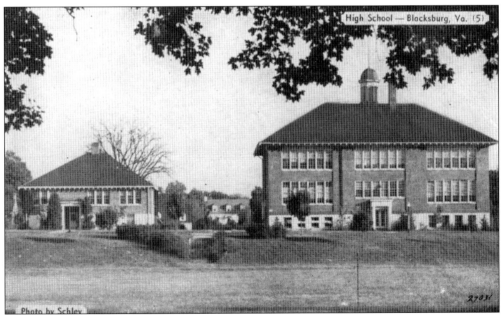

HIGH SCHOOL POSTCARD. These two buildings in downtown Blacksburg served as the town's high school from 1916 until 1954. The building have been preserved and restored by Virginia Tech and currently house the Architecture Annex and a media center. (DLA.)

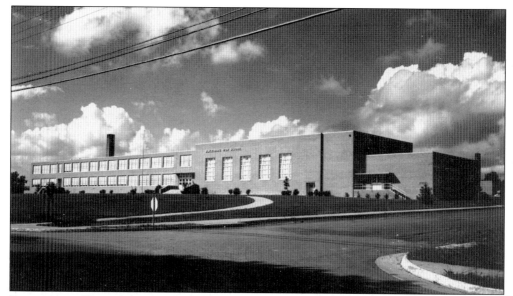

BLACKSBURG HIGH SCHOOL. By the early 1950s the town's population had outgrown the old high school and this new building was built on South Main Street not far from the earlier school. It opened in 1954 and served as the town's high school until 1974 when another new school was opened on Patrick Henry Drive. The old high school was then used as Blacksburg Middle School until 2002 when it was abandoned as a school after a new middle school was constructed and opened on Price's Fork Road. This photo was taken in 1961. (DLA.)

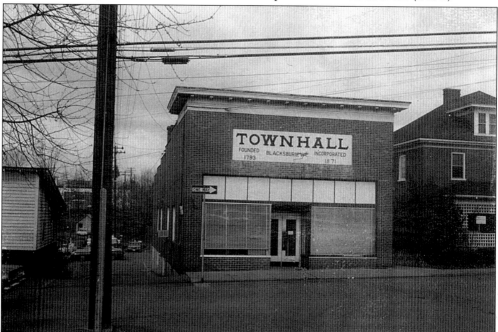

TOWN HALL. This building, which still stands on Jackson Street facing Church, was built in the mid-1920s as the Logan Martin Store. It was used from about 1942 to 1969 as Blacksburg's Town Hall until the current municipal building was constructed on Main Street. The building has also served as a jail, the police station, and Chamber of Commerce offices. (DLA.)

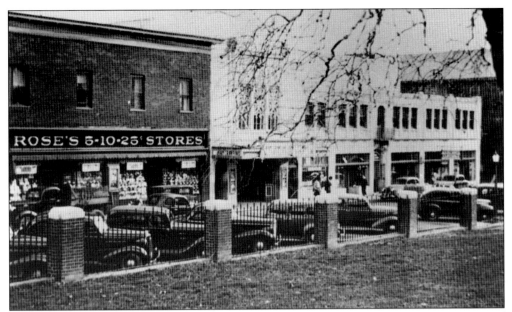

COLLEGE AVENUE. In 1922, the 19th-century building on the southwest corner of Main and College that housed Sarvay's Men's Furnishings store was torn down and replaced by this modern brick structure known as the Plank-Hoge building. In 1930, the Lyric Theater and its accompanying commercial block opened and transformed College Avenue into an important part of Blacksburg's downtown life. This was the third location of the Lyric Theater in town—the other two locations were on Main Street. The Lyric fell into disrepair in the 1970s but through an extraordinary effort by townspeople the theater has been lovingly preserved and restored to its original character. It continues its long tradition of serving the town as both a movie theater and a venue for live performances and community events. (JC.)

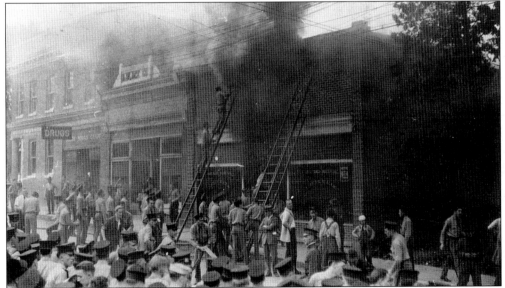

HARDWARE STORE FIRE. In 1923, the Blacksburg Hardware Company store on Main Street was gutted by a great fire. At the time, the university had the only fire department in town and the cadets turned out in droves as volunteers to fight the blaze. (DLA.)

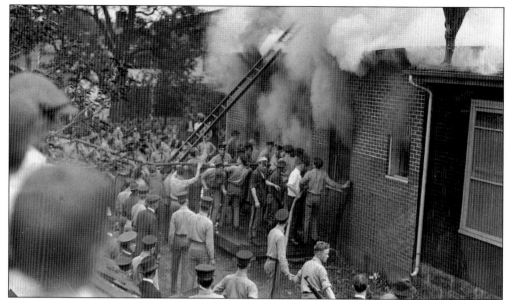

HARDWARE STORE FIRE, REAR VIEW. A view of the rear of the building as it burned in 1923. This building was constructed around 1900 and it served many purposes during its lifetime. Prior to 1920, it served as the Farmer's and Merchant's Bank with a barber shop and doctor's office on the second floor. After 1920, the ground floor was occupied by the hardware company. The interior of the building was not significantly damaged in this fire and from 1929 into the 1990s it was home to the venerable College Inn. Today that tradition continues and it is the home of Joe's Diner. (DLA.)

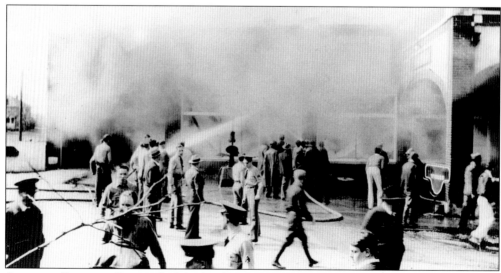

ANOTHER BUSINESS BURNS. In March of 1933 VPI cadets again turn out in large numbers to help fight a fire in town. This time the fire raged at Heavener's Blacksburg Motor Company at 400 South Main Street. This building is easily recognizable today as the home of Doc Robert's Tire Company. (DLA.)

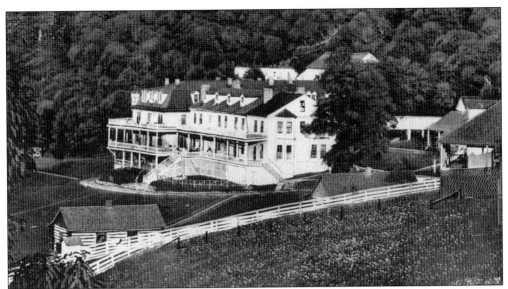

MOUNTAIN LAKE HOTEL. A much different looking Mountain Lake Hotel—just west of town over Brush Mountain in neighboring Giles County—is pictured here in this 1912 postcard. The hiking trails, lake, hotel, and restaurant at Mountain Lake have been popular destinations for Blacksburg residents and Virginia Tech students and their families for nearly 100 years. (DLA.)

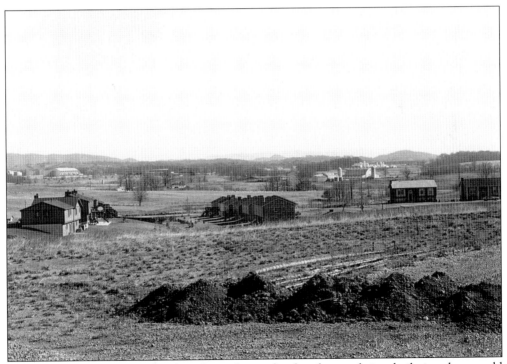

HETHWOOD DEVELOPMENT. This photo shows the first houses being built in what would become, by the late 1970s, Blacksburg's largest residential development. In the background of this photo, Virginia Tech farms can be seen along with Cassell Coliseum and Lane Stadium in the distance. (DLA.)

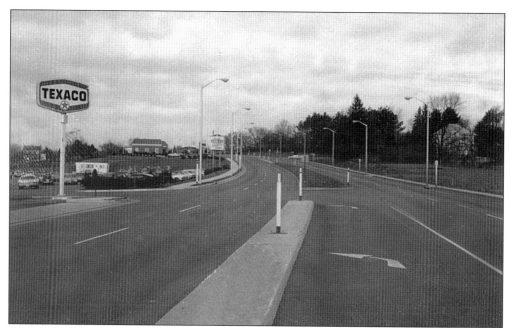

GABLES SHOPPING CENTER. The view coming into town from Christiansburg on South Main Street has not changed much from the 1960s photograph. There is still a Texaco station on the left and Gables Shopping Center has been updated. The shopping center which now lies on the east side of Main Street had not yet been constructed at the time this photo was taken. (DLA.)

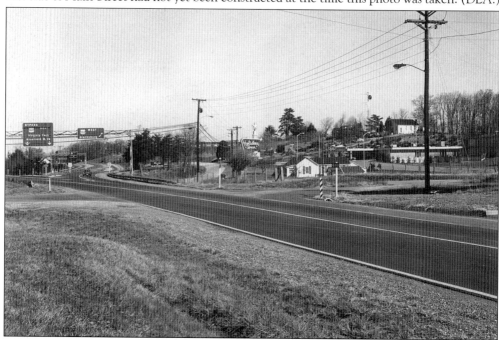

THE FIRST 460 BYPASS. In 1976, this new bypass skirted Blacksburg diverting traffic away from Main Street. Until the completion of the present 460 bypass and interchanges in 2002–2003, this is the scene everyone saw as they came into the Blacksburg area on U.S. 460 from Christiansburg. (DLA.)

34

Three

PEOPLE IN TOWN

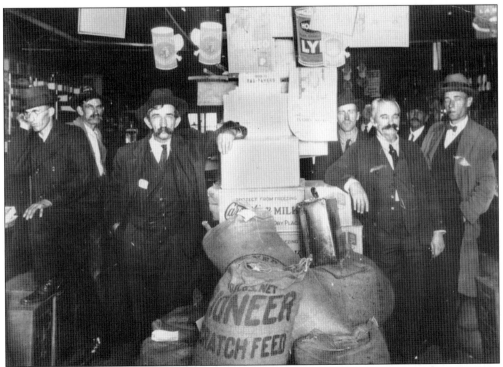

STANGER'S STORE. On the corner of Main and Jackson Streets, where the downtown Post Office now stands, for nearly 65 years there stood a most unusual structure. The photograph above shows the interior of Stanger's Store as it looked in the 1920s. As early as 1871, a general store, a barber, and a tin shop stood on this site. By 1927, it housed Stanger's General Merchandise as well as a pressing shop, shoe shop, plus boarders on the second floor. The building was torn down in 1935 to make way for construction of the new U.S. Post Office building. Most of the men shown in this evocative period photo are unidentified but on the far left is Mr. Dickerson and third from the left is the local magistrate "Squire" Stanger. (DLA.)

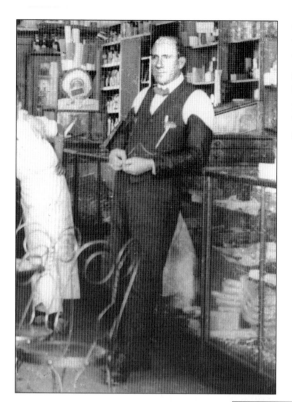

INSIDE ELLETT'S DRUG. In 1900, Dr. W.C. Ellett built the imposing brick building that still stands on the southeast corner of Main Street and College Avenue downtown. In this interior view, Dr. Pedigo and a clerk in the dry goods section of the store can be seen. (DLA.)

THE CIGAR COUNTER. No early 20th-century store like Ellett's would be complete without its cigar counter. Ellett's was the epitome of the classic establishment of its kind. In addition to cigars, you could go to Ellett's to buy medicines, dry goods, and candy. It also had a lunch counter and a beautiful soda fountain, which are featured in later photographs in this volume. (DLA.)

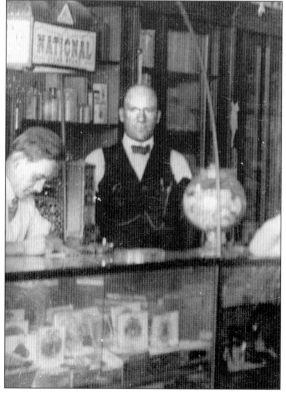

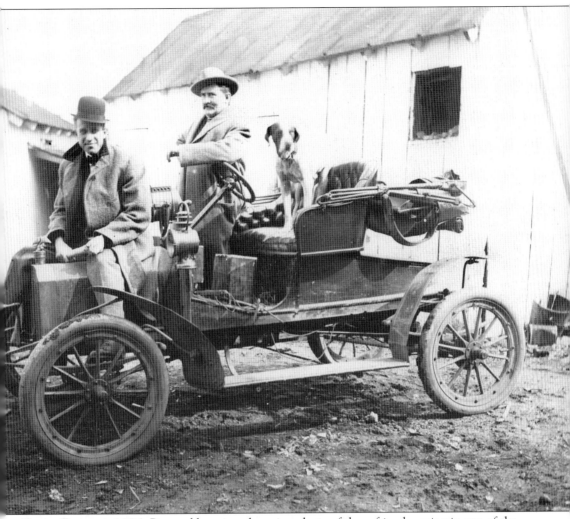

THREE FRIENDS, 1906. Pictured here is a charming photo of three friends posing in one of the first Ford motor cars to appear in Blacksburg. The man sitting on the hood of the car is unidentified but the other man is Dr. P.B. Ellett and the dog is Old Dan. (DLA.)

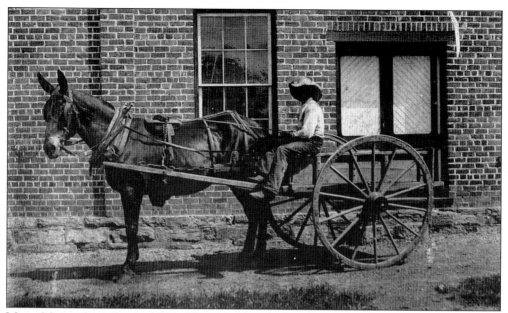

Man, Mule, and Cart, 1895. This is a photo of Sampson Campbell with his wagon and mule. In the 1900 census report from Blacksburg, one man in town identified his occupation as a wagon driver. Could this have been Sampson Campbell who is pictured here? (DLA.)

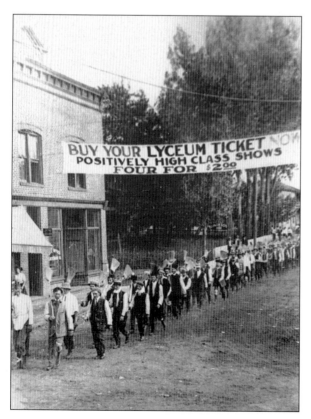

Lyceum Performance, c. 1905. A parade advertising an upcoming variety performance passes by Ellett's store in this early 20th century photo. Blacksburg has had a long tradition of independent community-based theater and other cultural activities which survives to the present time. (DLA.)

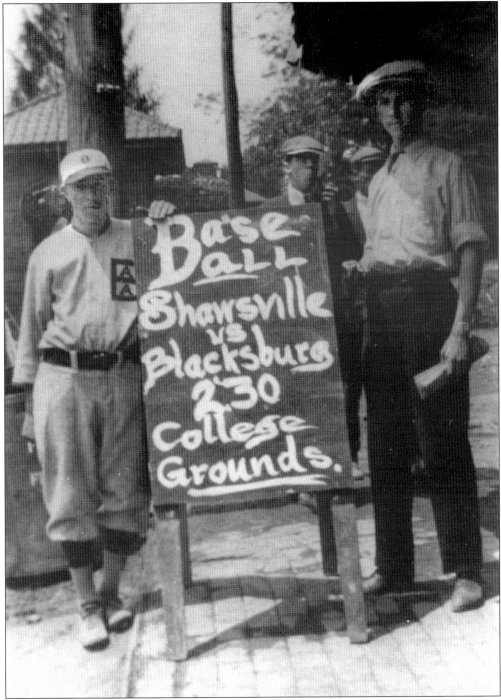

GAME DAY. Signs like this one were a popular and effective means of advertising everything from games to store specials in the early 20th century. They were used extensively by Main Street businesses. This sign announcing the baseball game between Blacksburg and nearby Shawsville was set up on the corner of Main and College. A portion of the old Alumni Gateway, built in 1912, can be seen in the background. (JC.)

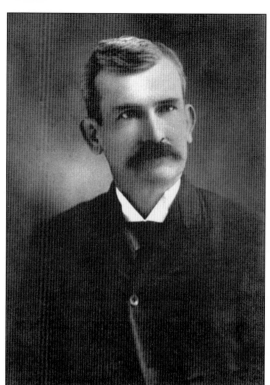

1908 PORTRAIT. A fine example of a studio photograph shows Dr. Keith Black of Blacksburg. Dr. Black passed away the year after this portrait was taken. (DLA.)

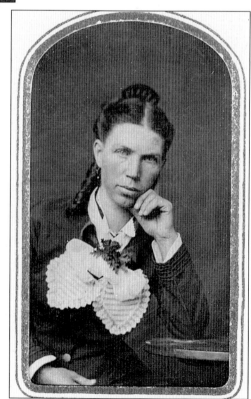

A PENSIVE LOOK. This studio portrait shows the subject, Mrs. C.A. Pugh of Blacksburg, in a rather thoughtful pose. This photograph was made of her in 1876. (DLA.)

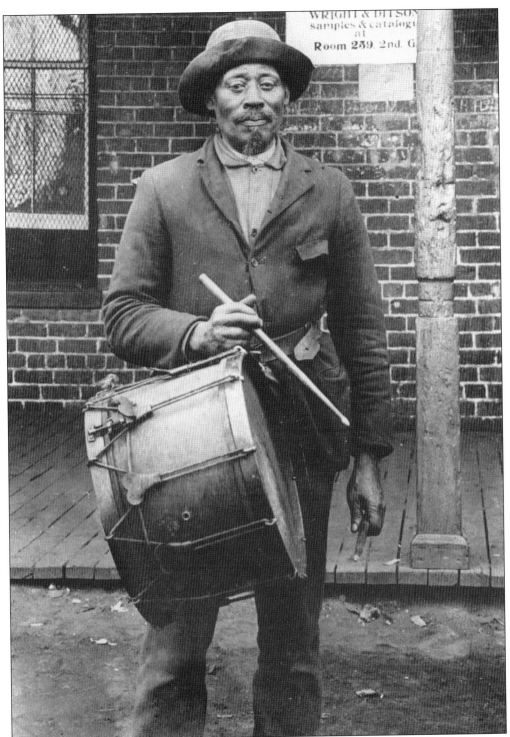

MR. SPORTY. The gentleman pictured in this photo from 1891 is Charles Owen. Little is known of him. On the reverse of the original photograph he was described as a "campus character" who was seen often around the university from around 1890 to 1909. (DLA.)

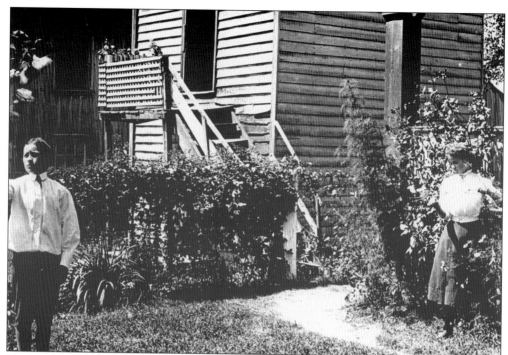

IN THE BACKYARD. In another exceptionally evocative photo from around 1900, Katie and Will Gray are pictured in the yard of their family's home which stood long ago at the corner of Church and Lee Streets. On the back of the original photo, the vines growing on the fence and porch are identified as honeysuckle and maderia. (DLA.)

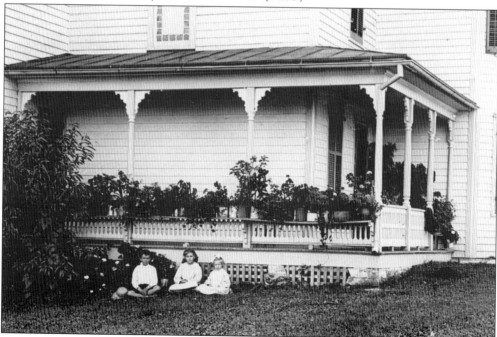

GROSECLOSE HOUSE, C. 1920. The children arranged neatly in front of the porch, the roses, vines, and a variety of potted plants punctuate this lovely domestic scene in Blacksburg. (DLA.)

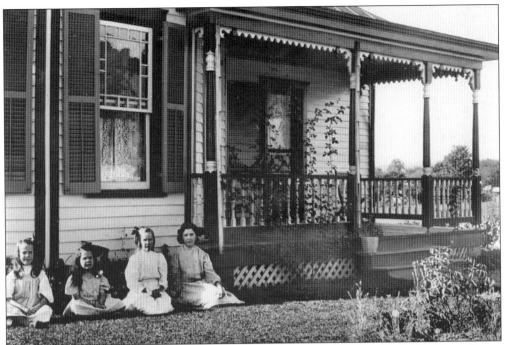

IN FRONT OF THE PORCH. A family is grouped on the lawn in front of their Blacksburg home in this undated photo. An interesting feature of this photo shows that the house and porch are trimmed in at least three different colors. Victorian homes became more colorful as easily mixed paints came on the market in the 1890s. (DLA.)

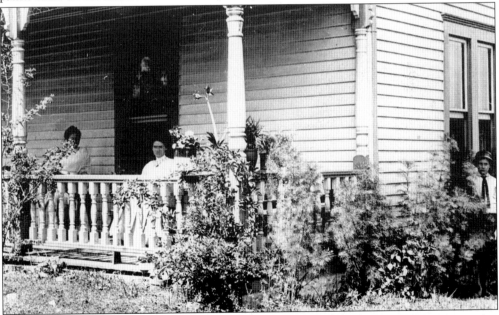

WOMEN ON THE PORCH, C. 1900. This photo shows two Blacksburg women enjoying a spring day on their front porch while a young boy lurks—perhaps unseen by them—around the corner behind a bush. Did he sneak into the picture at the last moment? The wire around the top of the porch is probably there to support the vines growing up the pillar on our left. (DLA.)

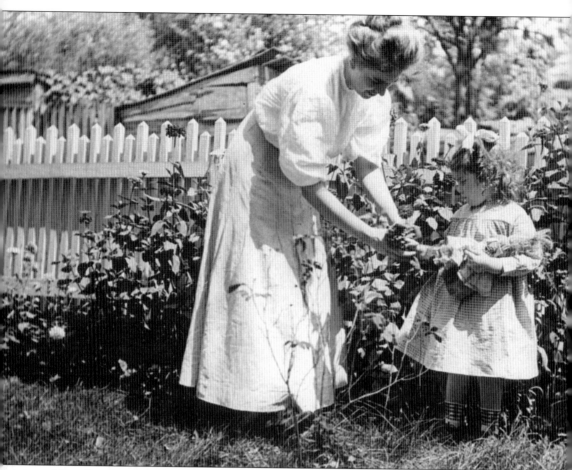

Mrs. Pedigo and Young Girl. In this evocative photo from the early 20th century, Mrs. Pedigo, the druggist's wife, seems to be helping her young daughter with a doll. Taken in either a side or back yard the photo is wonderfully detailed. From the doll baby to the little girl's socks, to the outbuildings and beautifully crafted picket fence, to the zinnias growing by it, this photograph perfectly captures the spirit and aura of this time long ago. (DLA.)

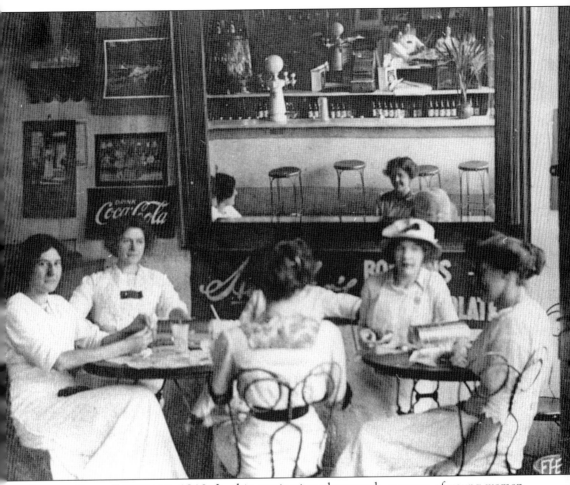

AT THE SODA FOUNTAIN, 1910. In this captivating photograph, a group of young women dressed to perfection enjoy a relaxing moment and a drink inside the soda fountain of Ellett's Drug Store. Multiple mirrors add to the character of the photo as do the signs, furnishings, calendars, and artwork on the wall. It has been suggested that one of the women in this photo is Mrs. Pedigo from the photo on the previous page. (DLA.)

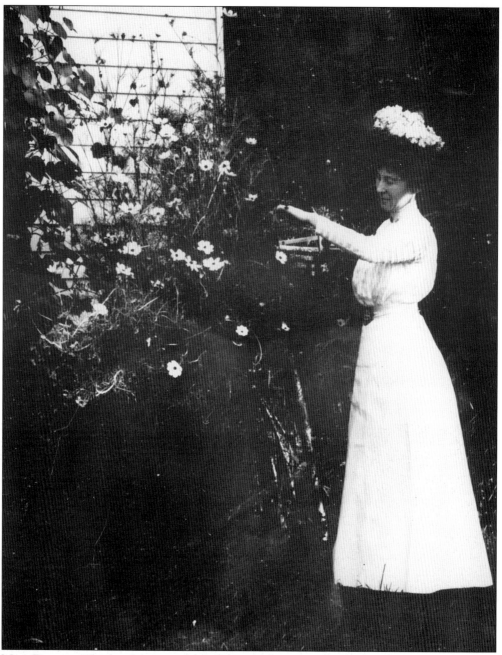

MRS. DUNLOP. This lovely woman in the beautiful dress attending to her cosmos flowers is Mrs. Dunlop. She taught music—particularly piano—in Blacksburg for many years. (DLA.)

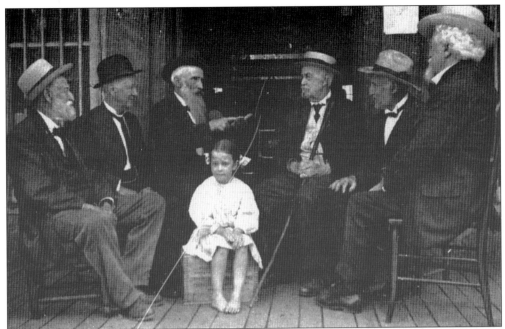

FORMER BLACKSBURG POSTMASTER, C. 1919. Byrd Anderson (third from the left) is seated in front of the Luster-Anderson Hardware Store, site of the present downtown post office. Anderson was co-owner of the store. The others engaged in the conversation are, from left to right, William H. Thomas; Dr. W.B. Conway, the first druggist in Blacksburg; Anderson; A.W. Luster, co-owner of the hardware; W.E. Hubbert, banker; and C.F. McKenna, a judge. The little girl seated on the box is Mr. Anderson's granddaughter, Ella Anderson. (DLA.)

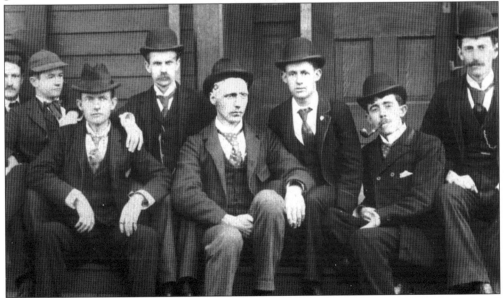

YOUNG MEN. This group of young men identified on the original photo as "leading citizens" certainly looks quite distinguished and fashionable. It was suggested by some longtime residents of Blacksburg that they were perhaps members of a "bachelor's club." None are identified and no date is given. (DLA.)

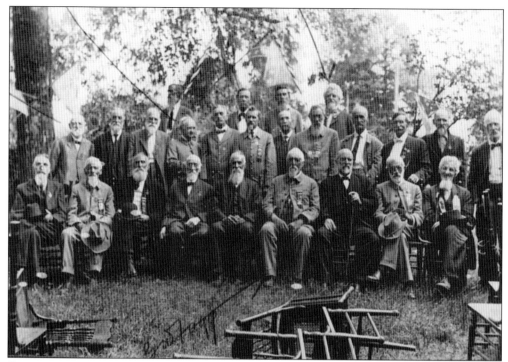

CONFEDERATE VETERANS. This remarkable photo shows the reunion of the Blacksburg Chapter of the United Confederate Veterans held at the home of William Turner in 1915. This gathering was to commemorate 50 years since the end of the Civil War. (DLA.)

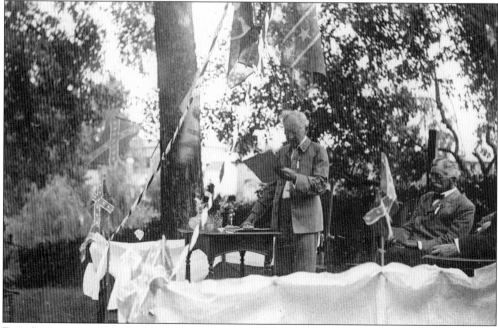

DR. CONWAY. In this photo, one can see Dr. W.B. Conway, Blacksburg's first druggist and author of an early history of the town, giving the address at the reunion of Civil War Confederate veterans in 1915. (DLA.)

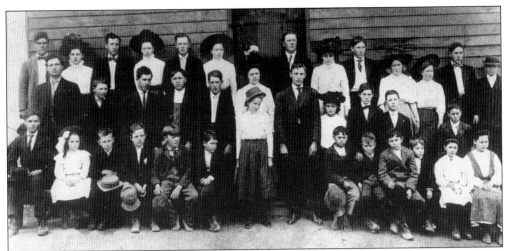

LUSTER'S GATE SCHOOL. Just outside the town limits of Blacksburg is the community of Luster's Gate in Montgomery County. In this photo students from the school pose for a group picture in 1904. An interesting fact about the photograph is that the young man in the back on the right with the hat on was not a member of the class but simply snuck into the picture. (DLA.)

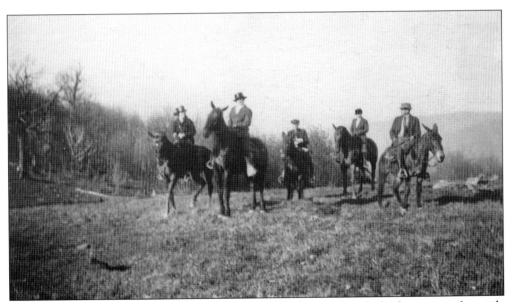

RIDING IN TOWN. In this photograph from the 1920s, five unidentified riders are out for a ride near Blacksburg. (JC.)

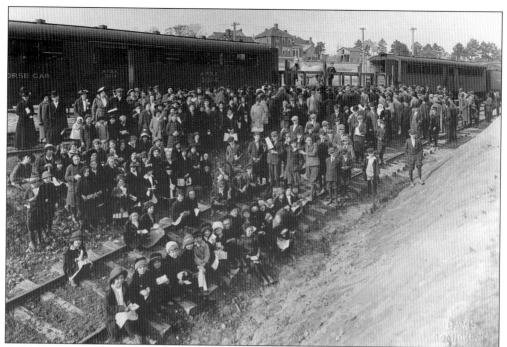

A School Trip. Two seemingly unrelated events appear to be going on in this undated photo at the train station. A large group of school children, perhaps about to go on an excursion, are sitting by the tracks. Also in the background the horse on the railroad car seems to be getting all the attention from the men gathered there. (DLA.)

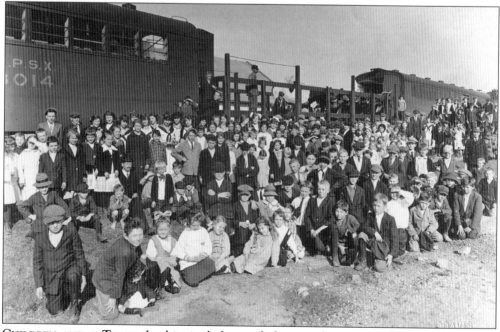

Children and a Train. In this similarly posed photograph, a group of children of varying ages pose beside another train (or possibly the same one) but with cows in the open car instead of horses as in the picture above. This photo is not dated. (DLA.)

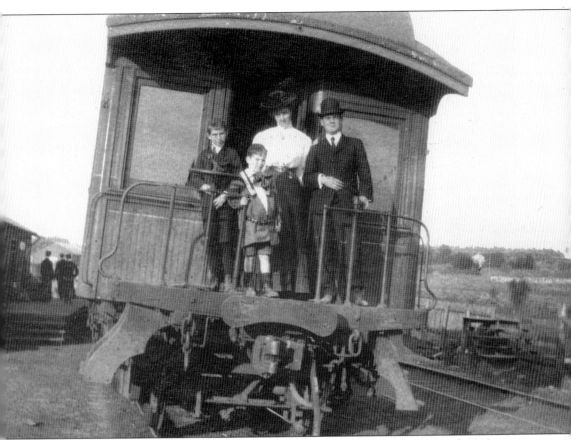

ON THE HUCKLEBERRY. In this photograph taken sometime between 1904 and 1913, one can see four passengers on the Huckleberry as it sits in front of the old train station. The people in the photo are identified as the following: ? Amiss, J. Davis, Duval Shultz, and Robert Shultz. (DLA.)

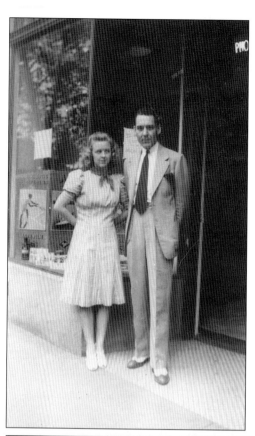

BLACKSBURG STYLE, C. 1940. This fashionably and well-dressed couple poses outside a downtown business, possibly Corner Drug. (JC.)

GENTRY STUDIOS. A group of people stop to admire historic photos of Blacksburg in the window of Gentry Studios, located where the old Tech Motel was on Draper Road. John Cline, owner of Gentry, has been collecting historic Blacksburg photos for many years and numerous images from his collection appear in this book. (DLA.)

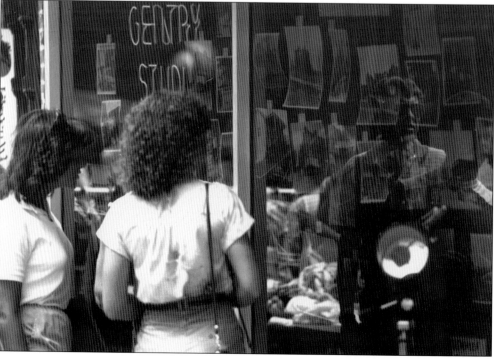

Four

BLACKSBURG'S
UNIVERSITY

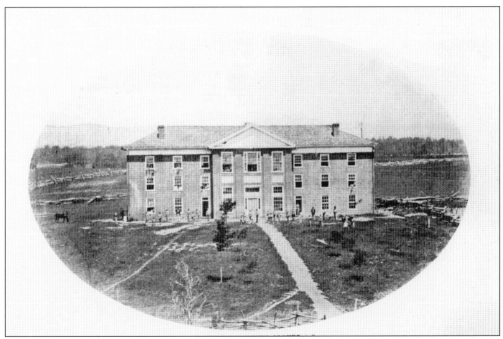

VPI As It Was When Opened, 1872. In 1851, Methodists in Blacksburg established the Olin and Preston Institute named for Stephen Olin and William Preston, prominent Blacksburg citizens of the day. In 1854, this imposing structure was built to house the school. In 1872 when Blacksburg was chosen as the site for Virginia's new agricultural university, this building was acquired and became the first building of the new Virginia Agricultural and Mechanical College. Altered and enlarged over the next 30 years this building burned to the ground in a spectacular fire at commencement time in 1913. (DLA.)

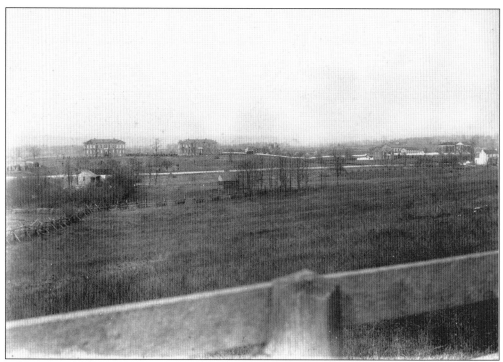

VPI CAMPUS IN 1887. By the late 1880s, the agricultural and mechanical college had grown significantly as this photo indicates and it was rapidly becoming the focus of much of the town of Blacksburg's business and commercial activities. (DLA.)

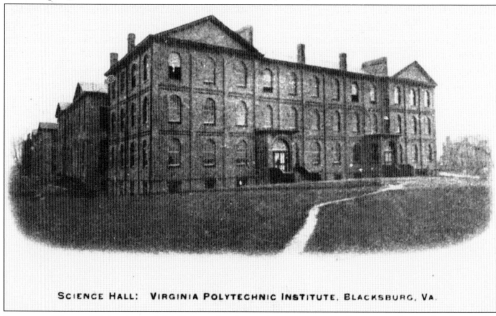

SCIENCE HALL: VIRGINIA POLYTECHNIC INSTITUTE, BLACKSBURG, VA.

SCIENCE HALL. This photo highlights the imposing structures that were being built on the university campus by the end of the 19th century. By 1900, the university was known by its new name, Virginia Agricultural and Mechanical College and Polytechnic Institute and was being referred to as VPI.

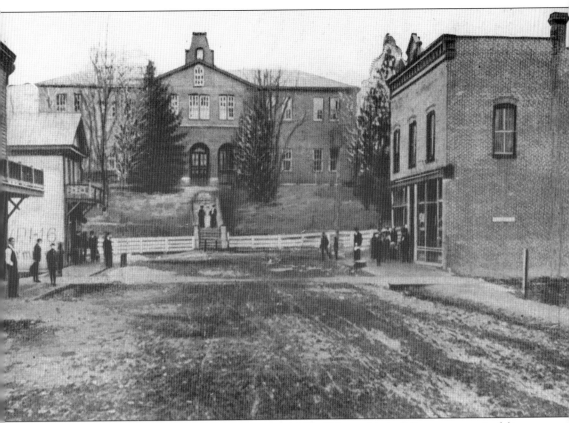

OLIN HALL AT THE END OF MAIN STREET, C. 1905. When this building was acquired by VAMC in 1872, it did more than change its educational focus from young Methodist women to young men interested in military life. It also substantially changed the commercial focus of downtown Blacksburg. In 1874, Main Street was moved so that it ended right in front of this building, as is clear in this photo. Prior to 1874, Main Street followed a line from the corner of Main and Roanoke Streets to a spot where the Lyric Theater sits today on College Avenue. In 1875, W.G. Sarvay moved his store building (left in the photo) from farther south on Main Street to this new corner of College and Main. The cupola on the college building plus the new front were added in 1904. (DLA.)

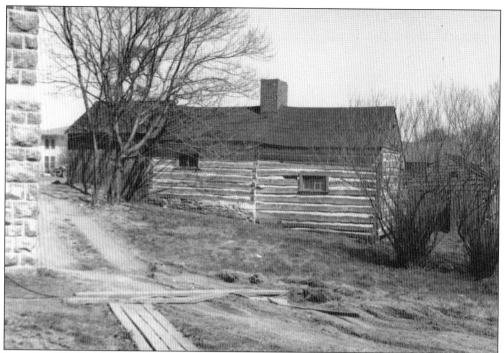

LOG BUILDINGS. This early 20th-century photo shows some old log structures on the VPI campus sitting alongside newer stone buildings. (JC.)

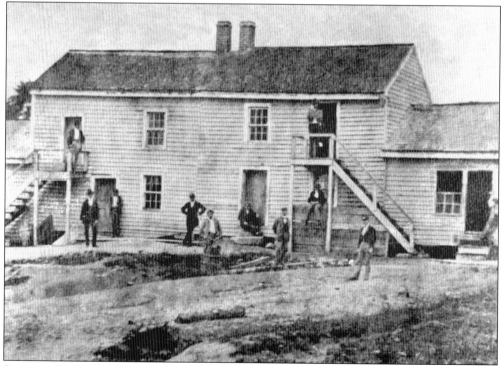

STUDENT HOUSING. Here is an early photo showing a building identified as "Hungry Hill" on the VPI campus.

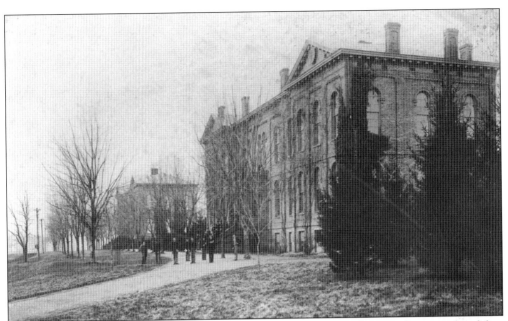

THE MAIN WALK. This is a photograph of the Main Walk at VPI showing the second and first academic buildings on campus. The photo is from the 1890s. (DLA.)

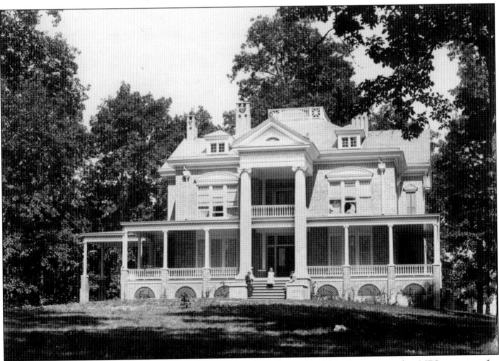

THE GROVE. This imposing home was built in 1902 in a secluded spot on the VPI campus for then president Dr. John McBryde, head of the university from 1891 until 1907. The following six presidents and their families lived in the house until 1971. It is still owned and used by the university. (JC.)

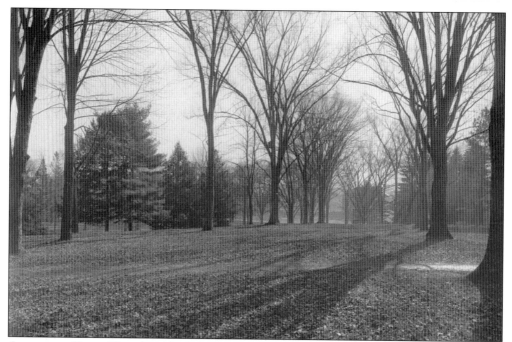

AVENUE OF ELMS. This photo from 1933 shows a portion of the VPI campus that was radically transformed by new construction in a controversial move. In 1936, the main entrance to campus was changed from its location at the intersection of Main and College to a spot up the hill where it is today. In 1946, the trees in this photograph were all cut down to make way for construction of the new college "mall." This photo shows what was called the "Avenue of the Elms" looked like prior to the construction. Construction on the mall began in 1950 and completed in 1951. (DLA.)

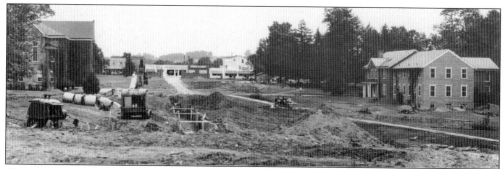

CONSTRUCTION BEGINS ON THE MALL. In this photo, construction on the mall has begun. North Main Street is seen in the background. The large white building, which still stands on North Main, is Deyerle's Store, known later as Hill's Store, built on that site in 1875. (DLA.)

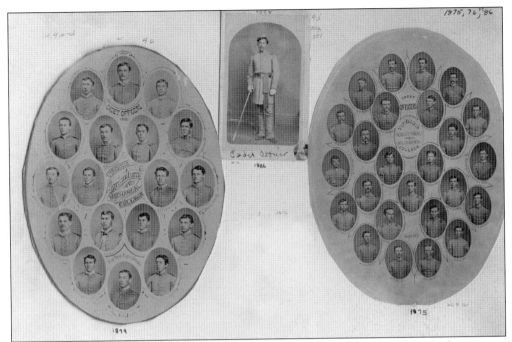

CADET OFFICERS. Looking rather like officers in the armies of the Confederacy these young men pose for the class pictures in 1875 and in 1879. From 1872 until 1964, all male students who attended VPI were required to participate in the Corps of Cadets. (DLA.)

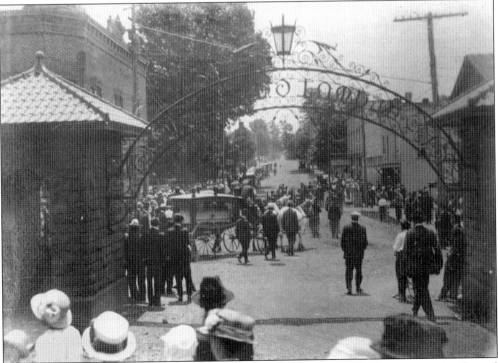

FUNERAL PROCESSION. This photo looking south down Main Street captures the funeral procession of Maj. James Patton Harvey. The photo was taken on June 15, 1915. (DLA.)

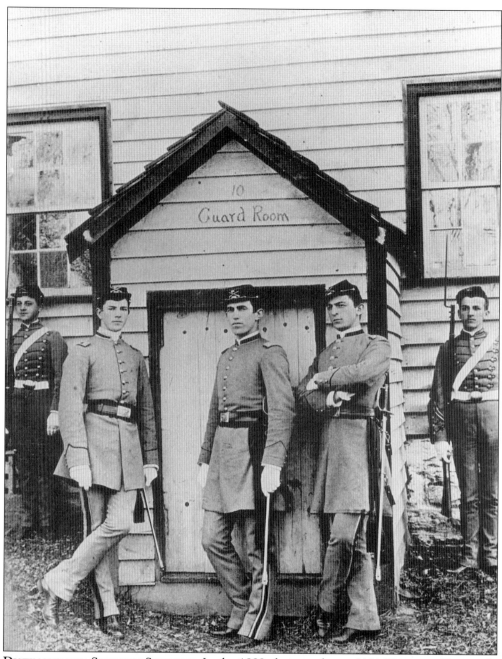

DISTINGUISHED STUDENT SOLDIERS. In the 1888 photo, cadets at VAMC pose stiffly outside their guard room. (DLA.)

CADET LIFE. Barracks accommodations were Spartan for these three young men at VPI around 1890. It looks as though they have turned in for the night. Everything is neat and in its place, including their guns with bayonets fixed and ready. Let's hope their bunks are sturdy for the sake of the young cadet on the bottom. (DLA.)

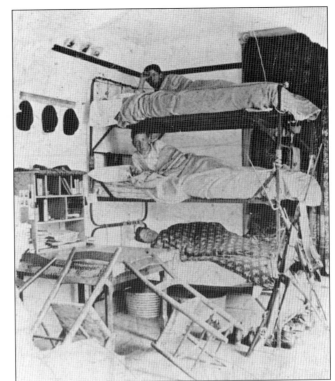

STUDYING. Sitting at his desk this young VPI cadet has all his important possessions close at hand, his books, his pen, his ink, his sword, as he studies at his desk in the barracks. (DLA.)

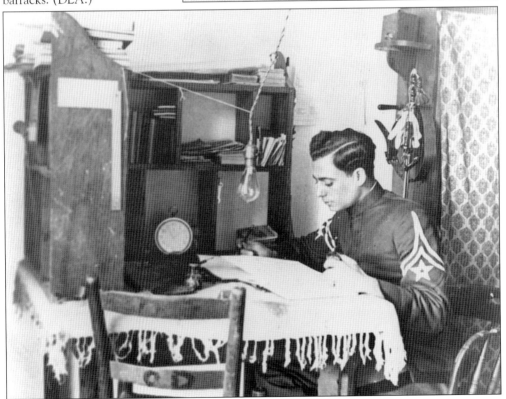

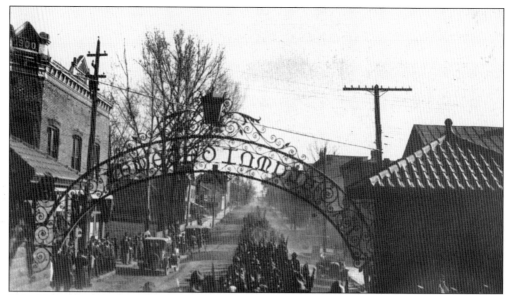

It's 1918. In this year, cadets could be marching off to war but they are not. In this photo taken November 28, 1918—World War I ended November 11th—a VPI battalion marches down South Main Street on its way to the train station. The destination is Roanoke for the annual football game between VPI and Virginia Military Institute. (DLA.)

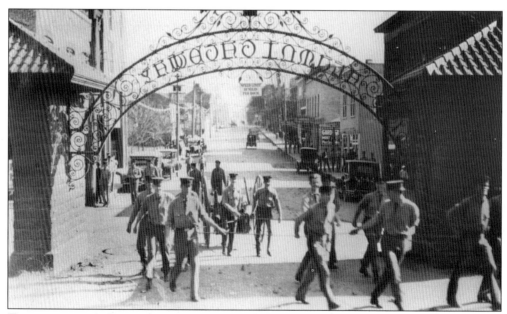

Through the Arch. In this photo from the 1920s, a group of cadets pulls a cannon through the Alumni Gateway. The gateway was built in 1912–1913 and served as the main entrance to campus until 1936 when it was torn down. In 1927, the iron arch was removed and the brick structures were moved back from the street and farther apart to accommodate a wider road into campus. (DLA.)

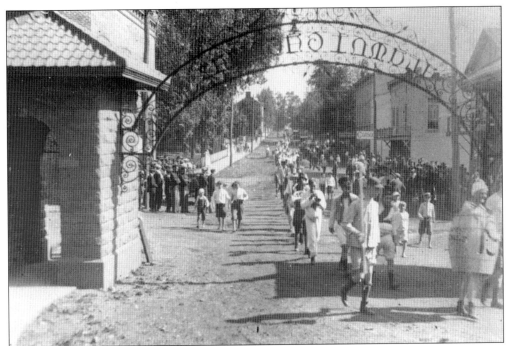

RAT PARADE, 1915. On the first warm Saturday of September each fall, the "rat" or freshman class was paraded through the downtown streets of Blacksburg by the sophomore class. It was intended to be a bit of sport but was obviously meant to humiliate as well. In this photo the Rat Class has arrived back at the Alumni Gateway after its march down Main Street. (DLA.)

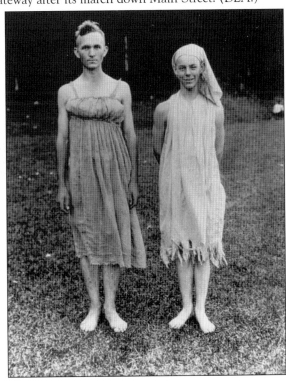

TWO RATS. In this early 1900s photo, two unfortunate young cadets pose in dresses that they were forced to wear in the annual Rat Parade. (DLA.)

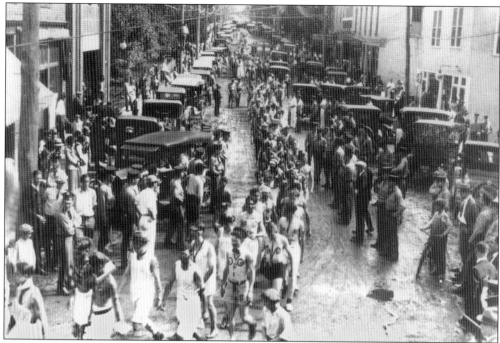

RAT PARADE, 1923. In this photo from September 1923, the Rats of the Class of 1927—painted up and jeered at—arrive back at the gate amid a throng of onlookers, both townspeople and upper class cadets. (DLA.)

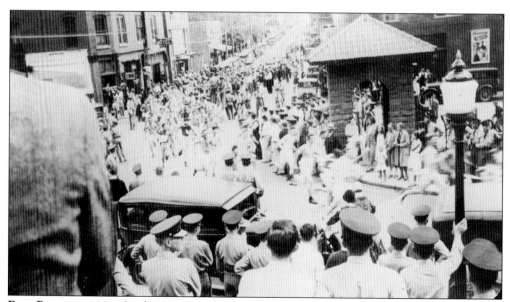

RAT PARADE, 1931. In this Rat Parade photo from 1931, an interesting detail is the movie poster on the side of the Corner Drug building; it advertises a Joan Crawford movie at the Lyric, which had just opened in its new (and present) location the year before. (DLA.)

VIRGINIA TECH MINSTRELS, 1923–1924. Black-face minstrel shows were an unfortunate vestige of the past that continued for too long at schools like Virginia Tech in the 1920s. They regularly featured comedy routines, skits, dancing, and jazz. (DLA.)

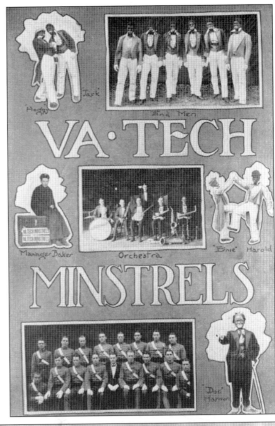

VPI GLEE AND MANDOLIN CLUB. At the turn of the century and stretching forward into the 1920s, Glee Clubs and mandolin orchestras were extremely popular on American college campuses. This 1897 photograph shows the VPI Glee and Mandolin Club's members arrayed with all their instruments. (DLA.)

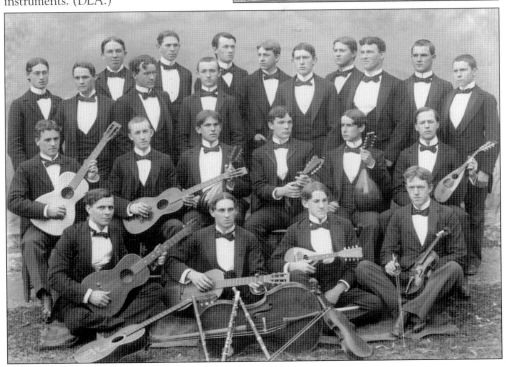

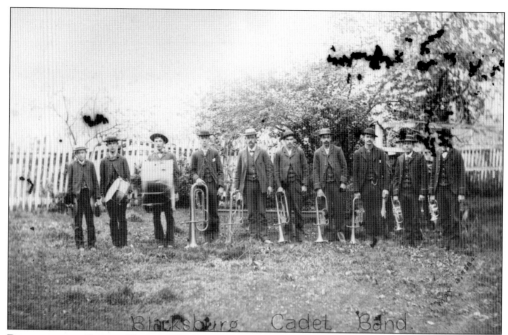

BLACKSBURG CADET BAND. This is a photograph of The Glade Cornet Band taken on May 3, 1884. This band acted as the post band for the VAMC cadet battalion from 1881 to 1892. (DLA.)

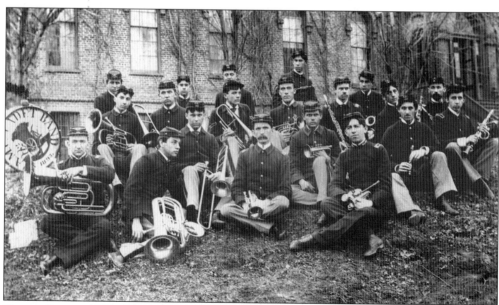

CADET BAND, 1893. This photograph shows the newly constituted and enlarged VAMC Cadet Battalion Band as it looked in 1893.

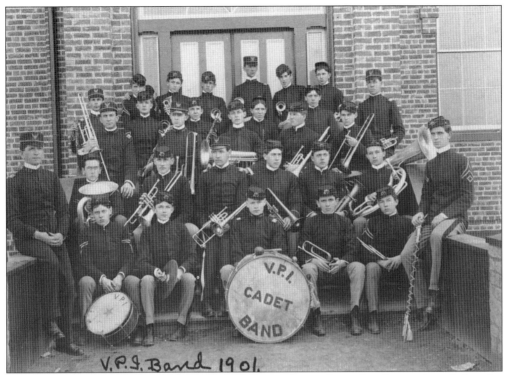

CADET BAND, 1901. This photo from 1901 shows an even larger band now identified as the VPI Cadet Band. (DLA.)

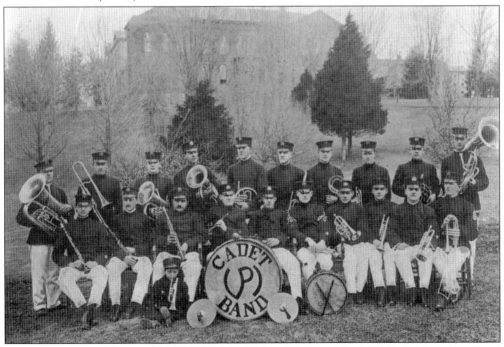

CADET BAND, 1913–1914. This is the 20-member version of the VPI Cadet Battalion Band as it looked in 1913. (DLA.)

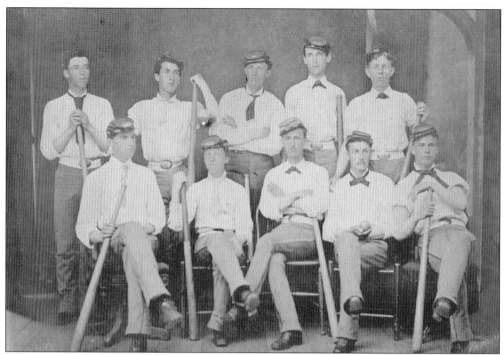

ALLEGHANY BASE BALL CLUB. This 1876 photo shows an early baseball club at VAMC. Their uniforms look curiously more military than sporting and by modern standards their bats are exceptionally long. (DLA.)

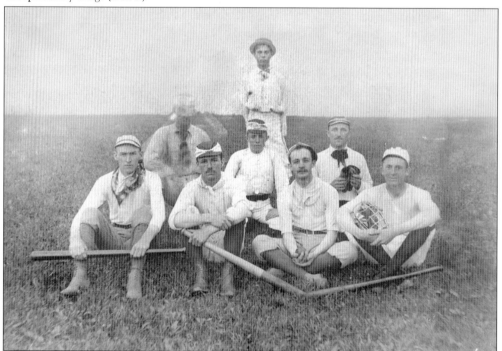

VAMC BALL TEAM. The college's baseball team for 1891—or at least a portion of the team—is pictured here. (DLA.)

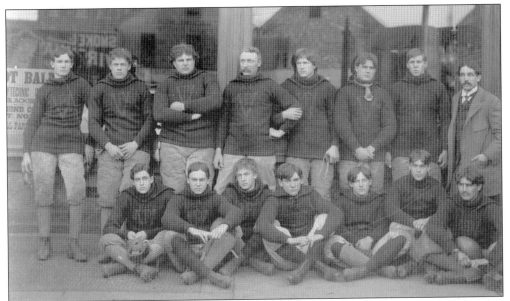

VPI FOOTBALL, 1897. This photo shows the VPI football team from the 1897–1898 season. They look like a pretty tough bunch of guys. (DLA.)

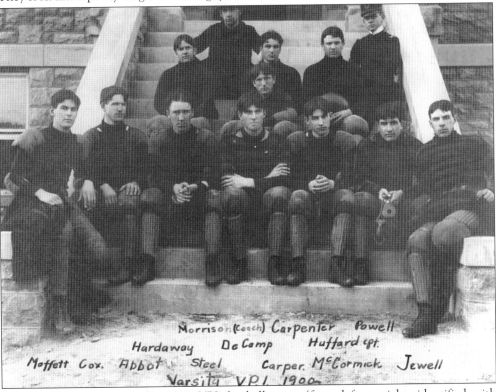

VPI FOOTBALL, 1900. The 1900 VPI football team (from left to right, identified with last names only) are the following: (front row) Moffett, Cox, Abbot, Steel, Carper, McCormick, and Jewell; (back row) Hardaway, DeCamp, Huffard, Coach Morrison, Carpenter, and Powell. (DLA.)

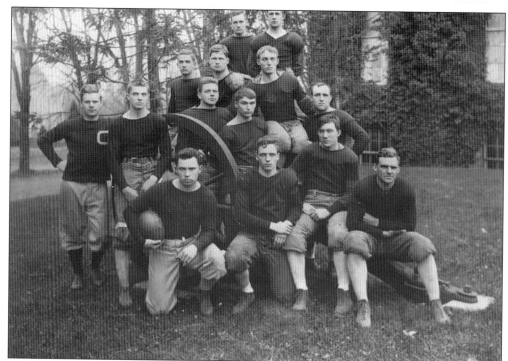

FOOTBALL TEAM. This in an undated and unidentified VPI football team probably from the 1920s. (JC.)

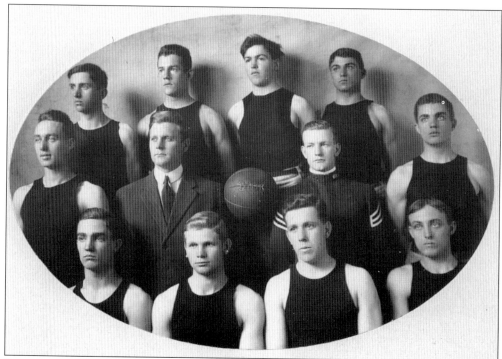

BASKETBALL TEAM. This undated and unidentified photo shows an early VPI basketball squad suited up and ready to play. (JC.)

OLD MILES STADIUM. This is a very early photograph of the old playing field known as Old Miles Stadium. As is obvious from the photo, it was located in the heart of town very close to the old Blacksburg High School buildings. (DLA.)

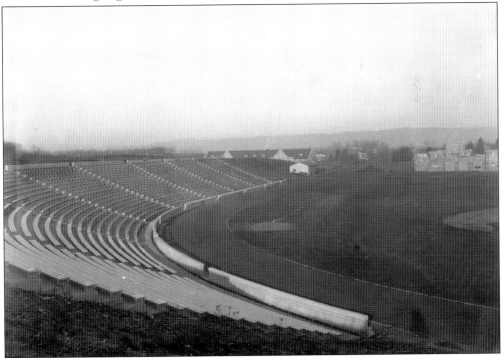

STADIUM. This photograph depicting the VPI stadium appeared in the 1933 edition of the *The Bugle*. (DLA.)

71

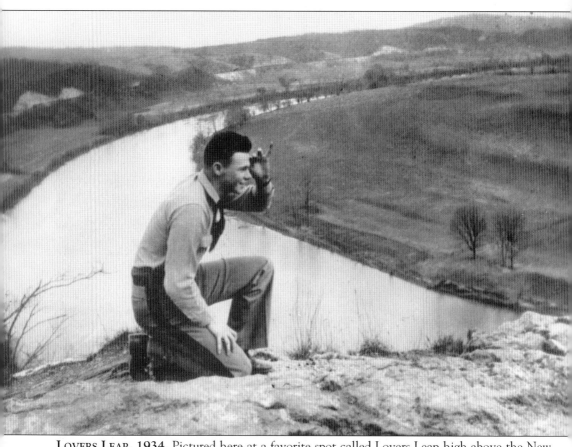

LOVERS LEAP, 1934. Pictured here at a favorite spot called Lovers Leap high above the New River near McCoy, Virginia is Virginia Tech cadet "Peanut" Ellis, class of 1934. (DLA.)

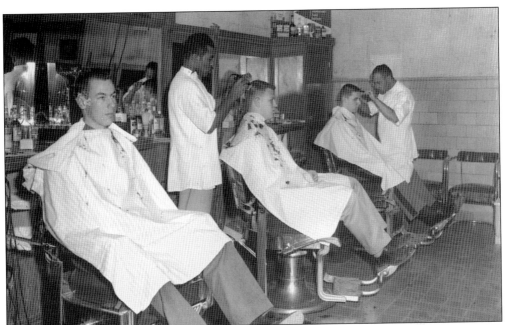

BARBER SHOP, 1950. This is a photo of the barber shop inside Squires Hall on the Virginia Tech campus. The two barbers in the photo are Fred Caldwell and Harold Cobb. (DLA.)

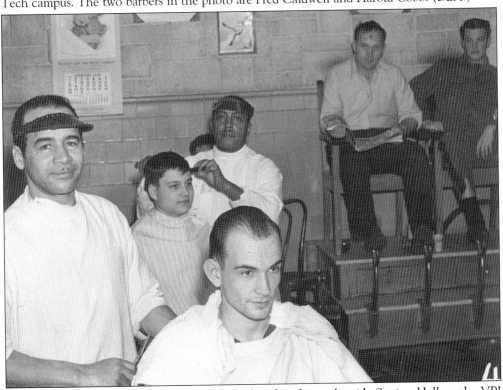

BARBER SHOP, 1946. Another shot of the barber shop located inside Squires Hall on the VPI campus. A calendar on the wall from the Leonard L. Brown Insurance Agency, which is still in business in Blacksburg, tells the year. (DLA.)

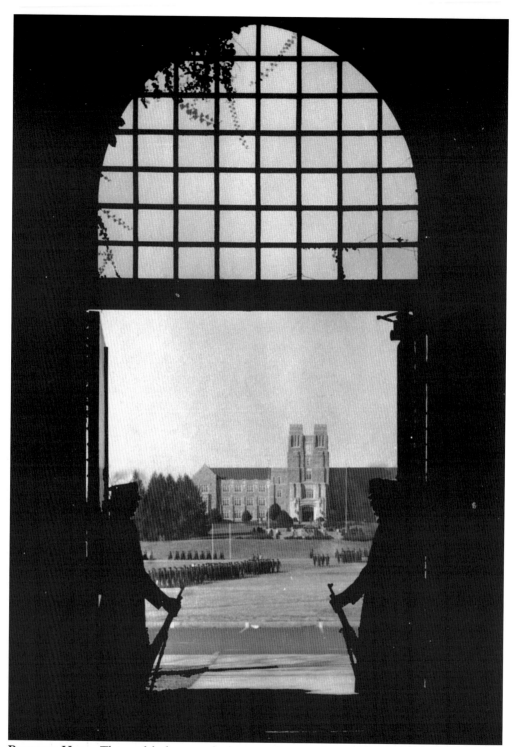

BURRUSS HALL. This artful photograph shows a glimpse of two cadets standing guard at the entrance to the War Memorial Gym while other cadets march in parade formations on the drill field in front of the recently completed Burruss Hall. The picture is from 1941.

Five

CARS BUT
MOSTLY TRAINS

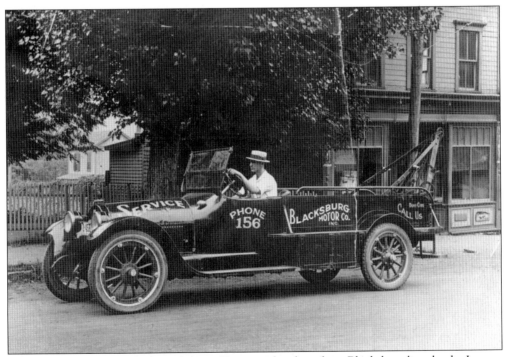

"DON'T CUSS CALL US." In 1919, two Heavener brothers from Blacksburg bought the Luster-Black garage on Main Street. In 1921, they opened the Blacksburg Filling Station and in 1922 they opened a very successful Chevrolet dealership called The Blacksburg Motor Company Incorporated which they operated until 1957. This photo from around 1930 shows Mason Heavener parked in the Blacksburg Motor Company's service vehicle. (JC.)

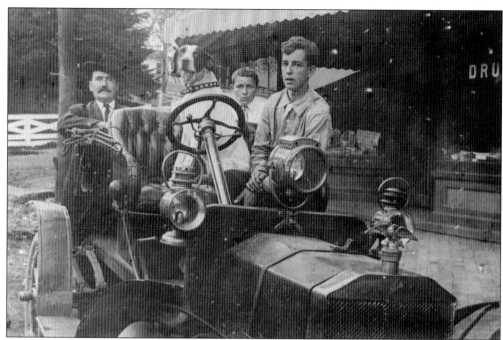

OLD DAN DRIVING. This engaging photo shows Bill Ellett and his dog Old Dan sitting in one of the first Ford automobiles in Blacksburg. They are parked in front of Ellett's Drug Store and have obviously attracted some attention. The year is 1906. (JC.)

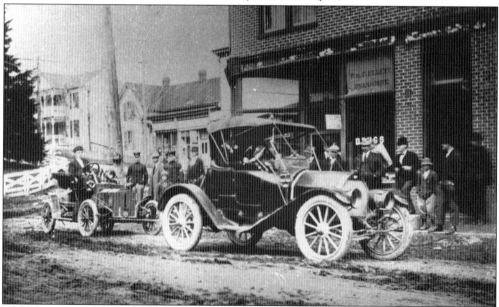

TWO EARLY AUTOMOBILES. Two cars, an older and a newer Ford, sit in front of Ellett's. In this c. 1915 photo, the original configuration of College Avenue as it curved up the hill is pictured. The fencing that then surrounded the college grounds is also apparent. The large house in the photo with the double porches is the Keister House, also known as the "White Swan," which later belonged to John Lewis Eakin and later still to John Hoge Woolwine. The house is still there, though changed somewhat, and houses the offices of Raines Real Estate. (JC.)

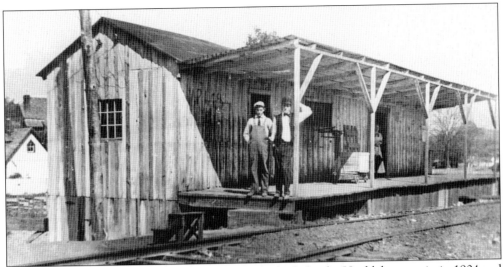

FIRST TRAIN STATION. This tiny train station was built for the Huckleberry train in 1904 and was located behind the present site of the Montgomery-Floyd Regional Library in Blacksburg. In 1913, Norfolk and Western Railroad tore this station down, improved the tracks, built a trestle over Water Street (Draper Rd.), and built a new railroad station where the current Blacksburg municipal building is located on South Main Street. (N&W Collection, DLA.)

THE OLD STATION. Pictured here is another view of the original Huckleberry train station in Blacksburg.

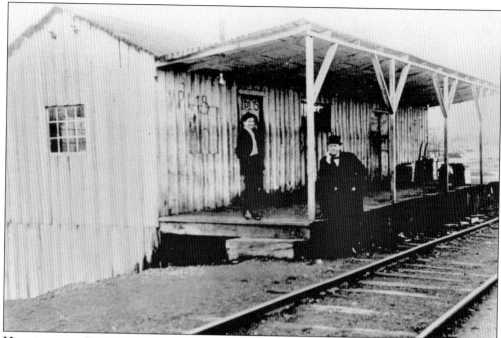

HUCKLEBERRY STATION, 1909. In this photo of the old train station, VPI football scores are painted on the door and on the side of the building. This was apparently a popular means of spreading news about the outcomes of games to travelers and townspeople alike. Generations of VPI cadets used this and the later station when the corps traveled out of town to football games. (DLA.)

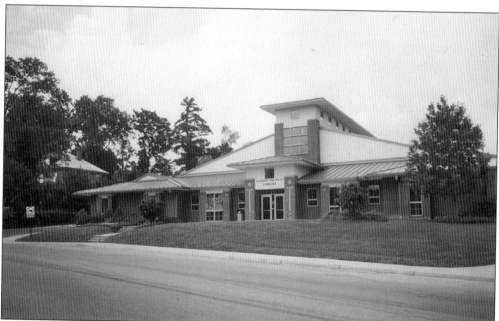

THE TOWN LIBRARY. This shows the Montgomery-Floyd Regional Library in Blacksburg. This interesting building was constructed in an architectural style reminiscent of the old train stations of the last century. It is built on the site of the original Huckleberry Station. (AP.)

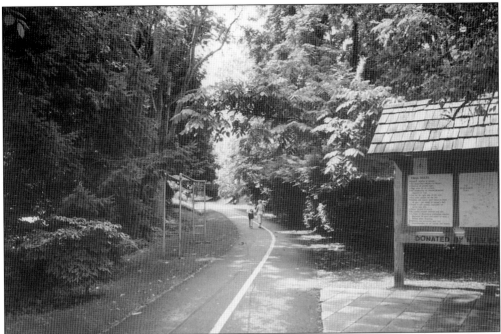

THE HUCKLEBERRY TRAIL. These two photographs show the Blacksburg entrance into the Huckleberry Trail, a very popular walking and bike path that starts at the library and follows the old Huckleberry railroad right-of-way that first connected Blacksburg to Christiansburg by rail in 1904. The Huckleberry, or the bike path as it is popularly known, stretches for over five miles between Blacksburg and the New River Valley Mall. A huge outpouring of popular support and financial assistance by many Blacksburg citizens helped this thoroughfare become a reality in the 1980s.

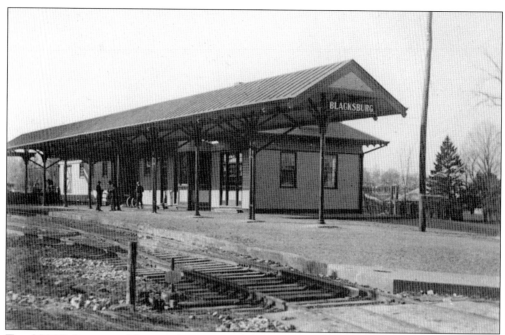

THE N&W STATION. This is a front view of the railroad station built in Blacksburg in 1913. The house in the background is possibly one known as Five Chimneys, which still exists today on Draper Road.

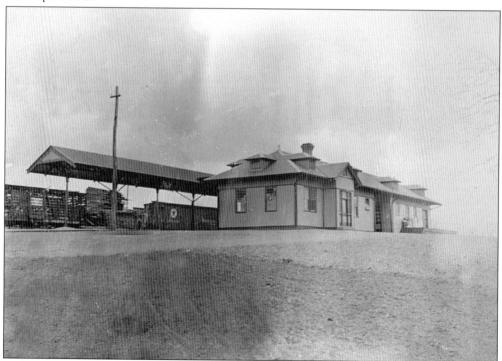

THE REAR OF THE STATION. In this rear view of the new N&W station in Blacksburg, the sign that can be seen in the photo at the top of the page, with the word "Blacksburg" on it, is not present.

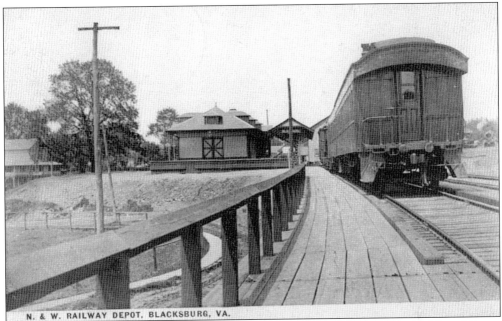

N. & W. RAILWAY DEPOT, BLACKSBURG, VA.

TELEGRAPH POLES. In 1874, Blacksburg was one of the first communities in the United States to establish a telegraph line that was independent of a railroad line. VAMC students and faculty were responsible for bringing in the telegraph line. Due to the efforts of VAMC President McBryde, Blacksburg was also able to acquire and establish electric lighting in the downtown area in the very early years of the 20th century as well. (DLA.)

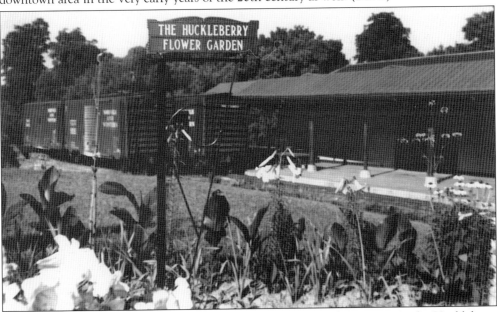

THE HUCKLEBERRY FLOWER GARDEN. After the trains stopped coming into the Huckleberry in 1958, flowers began to appear in between and alongside the abandoned tracks. Most of these flowers were planted and tended by David Slusser and lifelong resident of Blacksburg and bookkeeper for the Blacksburg Motor Company for several decades. His sister referred to him as "Blacksburg's first beautifier." (DLA.)

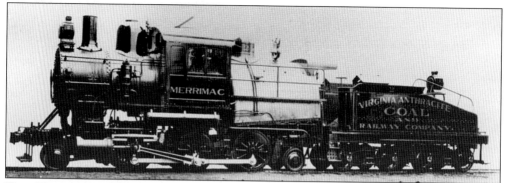

THE HUCKLEBERRY ENGINE. This photo shows the original Huckleberry train engine #2 in 1904. The Huckleberry line was originally established in 1904 to connect Blacksburg to the Merrimac anthracite coal mines which were located approximately halfway between Blacksburg and Christiansburg. (DLA.)

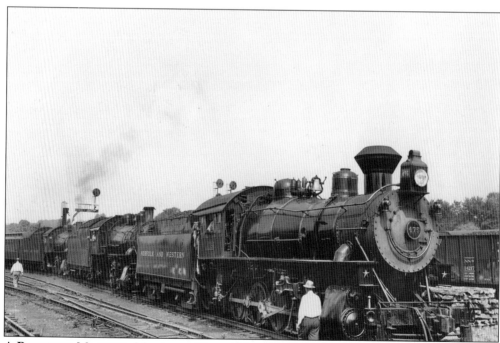

A POWERFUL MACHINE. Massive and beautiful coal burning steam engines such as these pulled passenger cars into and out of Blacksburg as in this photo from the 1940s. Even with train service to Christiansburg, longtime town residents recall that in this era it was still difficult getting anywhere from Blacksburg. (DLA.)

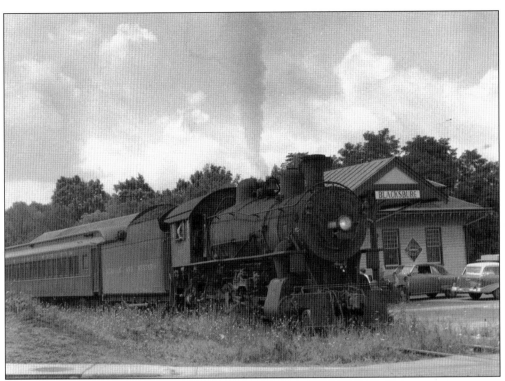

THE LAST RIDE. This is a photo that is said to show the last run of the Huckleberry out of Blacksburg. This sad and momentous event took place in 1958. Train service was late coming to Blacksburg and lasted only slightly longer than 50 years. A Blacksburg Railway Company was incorporated in 1874 but train service did not begin until 1904. The Huckleberry route was designed and partially built by a VPI engineering professor and some of his students. (JC.)

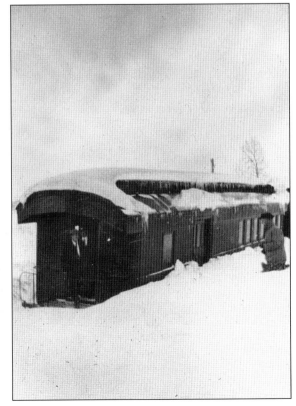

SNOWBOUND. In this photo the Huckleberry is snowbound at the Blacksburg station during the winter of 1914. (DLA.)

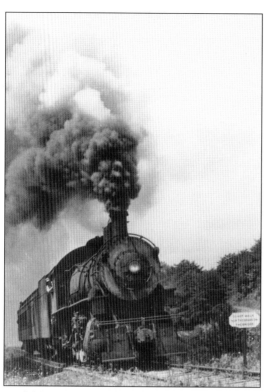

THE STEAM ERA. A great and majestic steam locomotive chugs its way along the Huckleberry line near the Merrimac mines in Montgomery County just outside Blacksburg. (DLA.)

601 ENGINE. In this dramatic photo, a powerful 601 steam engine pushes through a street crossing on a snowy day in Blacksburg. (DLA.)

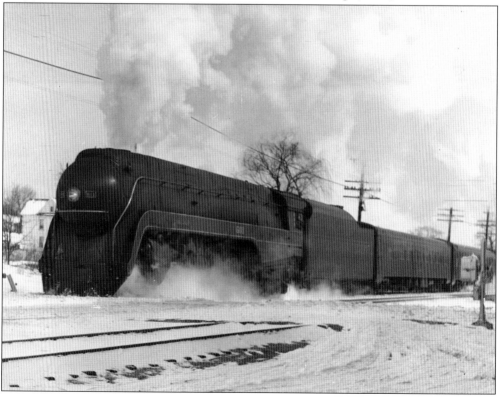

Six

BUSINESSES IN BLACKSBURG

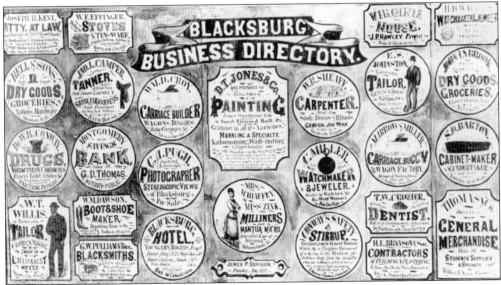

BLACKSBURG BUSINESS DIRECTORY, 1877. It was popular for towns in the 19th century to publish business directories such as this one, which were, of course, good sources of advertising. Advertising in this age was much more straightforward and matter-of-fact than it is today. In Blacksburg's directory from 1877 (pictured here) one finds advertisements for the Virginia House Hotel and the Blacksburg Hotel, both on Main Street, plus ads for several groceries, carriage builders, tanners, painters, tailors and boot makers, a photographer (Mr. Pugh), watchmakers, druggist (Dr. Conway), a bank, an attorney, a milliner, dentist, contractor, and a blacksmith. (DLA.)

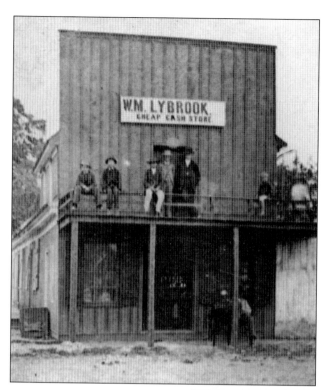

CHEAP CASH STORE. W.M. Lybrook owned a block of property on Church Street between Jackson and Roanoke Streets. He built a fine two-story house, a row of low-cost rental properties, and his store on this property in the 1870s. This photo shows his "Cheap Cash Store," which fronted on Roanoke Street. Stretching out behind the store are his rental units, known as Lybrook's Row. His house was torn down in the 1930s to make way for the expansion of the Episcopal church. The rest of his property was torn down in the 1960s. (JC)

HACK STATION AND POST OFFICE. This is Deyerle's Hack Station and Post Office in a photo dated *c.* 1875. The sign on the building announces hack tickets to Yellow Sulphur Springs resort and to Bange. Bange was the local name for Cambria where the train station in Christiansburg was located. This building was situated on Main Street between Roanoke and Lee Streets. In 1875, Deyerle moved his business to a new larger building that he had built on a site on North Main Street opposite the new college when Main Street was relocated. (DLA.)

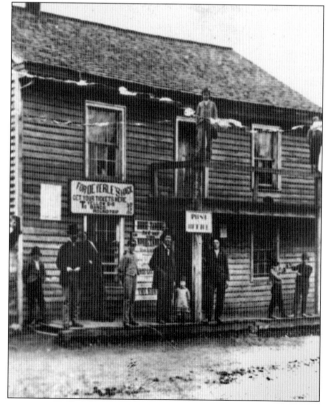

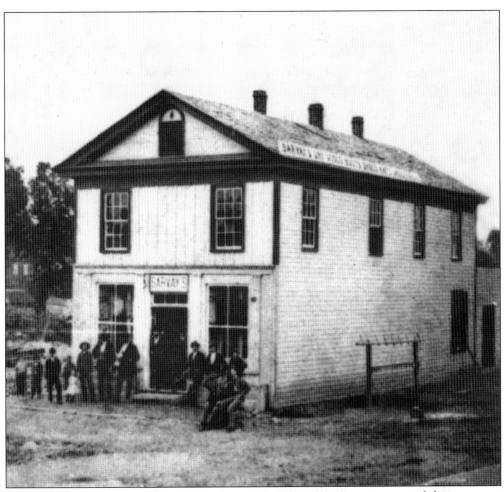

SARVAY'S STORE. From 1875 to 1922, this store, built by W.G. Sarvay, occupied the important corner of Main and College. It was later torn down and replaced by the modern brick structure, known as the Plank and Whitsett building, which stands there today. Sarvay's was a men's furnishing (clothing) store and was moved to this spot in 1875 to take advantage of the location's proximity to the new college. Sarvay, like Deyerle, had been in business farther south on Main Street but moved his business when the course of Main Street was altered in 1875. After this change was made, a significant portion of Main Street's commercial focus shifted to the area closer to the college campus. (DLA.)

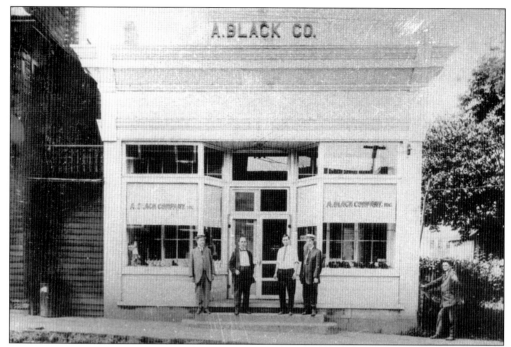

A. Black Company. The proprietors of the Alexander Black Company stand in front of the store in the early 20th-century photo. The building pictured here still stands on Main Street and was home to Mainstreet Bazaar for many years. (JC.)

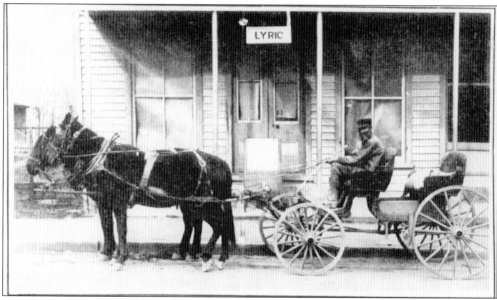

The Lyric Theatre. Blacksburg has had a Lyric Theater for nearly 100 years. This photo shows the first Lyric in 1910, the last year in its first location. In 1909, S.R. Minter opened the theater in a portion of the Deyerle store building on North Main Street, pictured here. In 1910, the Lyric moved to its second location on Main Street in the brick building at the corner of Main and Jackson Streets which is currently occupied by Big Al's restaurant. The Lyric remained in this location until 1922 and then opened in its current location in 1930. (JC.)

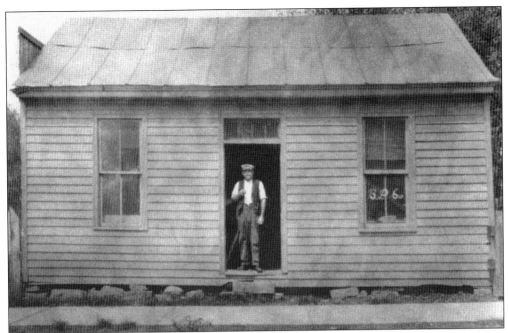

MAYOR'S OFFICE. An unidentified Blacksburg man stands in the doorway of this building identified as "the mayor's office" in this early photo. The primitive construction methods of some buildings like this one can be readily seen in the way this building simply sits on top of some stones that serve as its foundation. (DLA.)

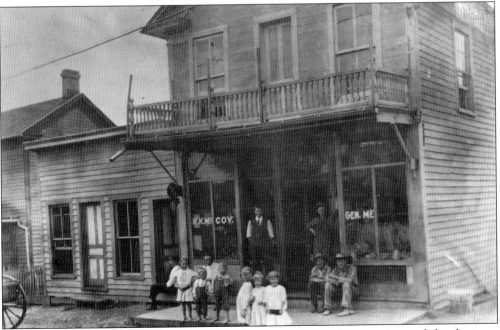

McCoy General Merchandise. In this charming photo, the proprietor of this business poses in front of his store with possibly members of his family. This business was located on the northeast corner of North Main and Turner Streets. It was later known as Hutchinson's Store. (JC.)

STROUBLES CREEK. This photo from the early 20th century shows how Stroubles Creek used to run through the center of town across Main Street. The large structure on the left in the photo is identified as Dr. Gardner's building and was once home to an early Kroger store and Tech Drug. (DLA.)

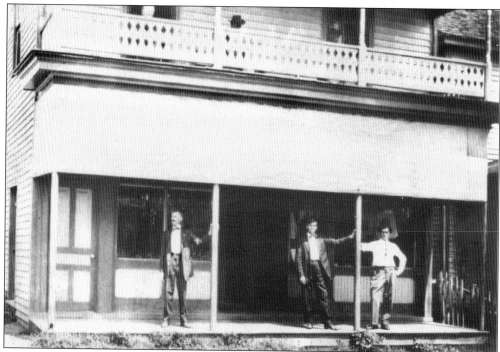

POSING FOR THE CAMERA. In this period piece several men pose in front of an unidentified building in Blacksburg. This is possibly the Roop House, which stood on Main Street for many years. (DLA.)

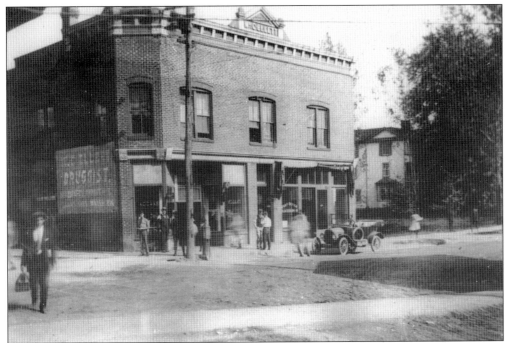

ELLETT DRUG AND POST OFFICE. This photo shows an important building as it looked in 1910. Notice the beautiful house next door; isn't that Dr. Ellett's 1906 Ford parked out front? (DLA.)

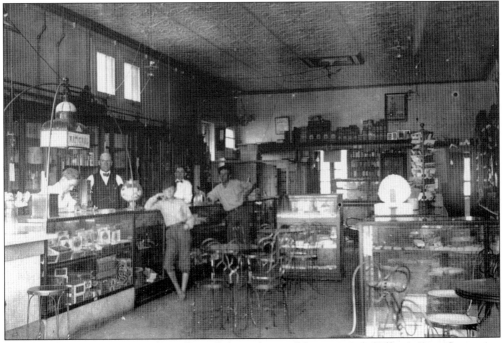

INSIDE ELLETTS. In this wonderfully revealing photo of the interior of Ellett's Drug Store, one can see a full view of what an early 20th-century business of this nature looked like. Dr. Pedigo and his clerks are behind the counter attending to the needs of the customers. In the left foreground of the photo, a small glimpse of the soda fountain is visible. (DLA.)

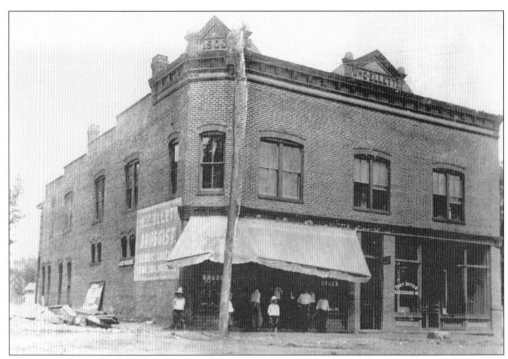

POST OFFICE BLACKSBURG, VIRGINIA. When this building was built in 1900, the post office moved into it and stayed until 1923. Then the post office moved across the street to the new Plank and Hoge building. In 1934, the Ellett Building underwent a major face lift when a portion of it was converted to the William Preston Hotel.

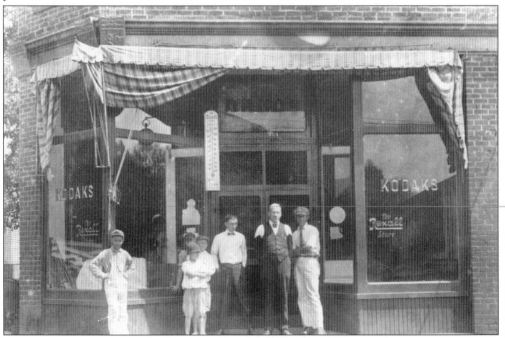

KODAKS FOR SALE. Dr. Pedigo and his clerks pose in front of the updated storefront of the Ellett Building in this undated photo. (DLA.)

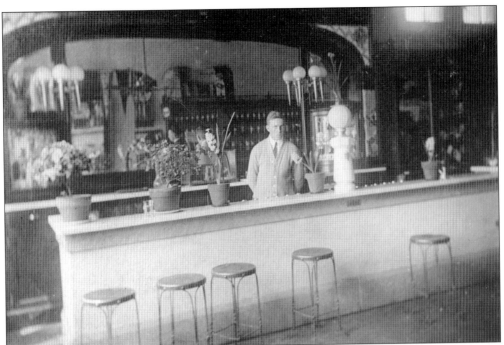

THE SODA FOUNTAIN. Every detail of a 1900 soda fountain is shown clearly in these two photographs of the soda fountain inside Ellett's Drug Store in Blacksburg. Everything from the metal stools to the marble counter top and the plants are in perfect order. In the bottom photo, the soda "jerk" waits on three customers under the watchful eye of Dr. Pedigo. (DLA.)

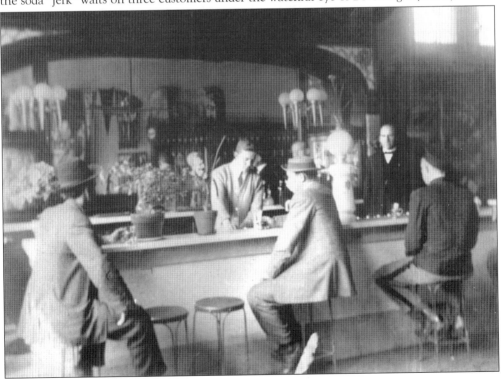

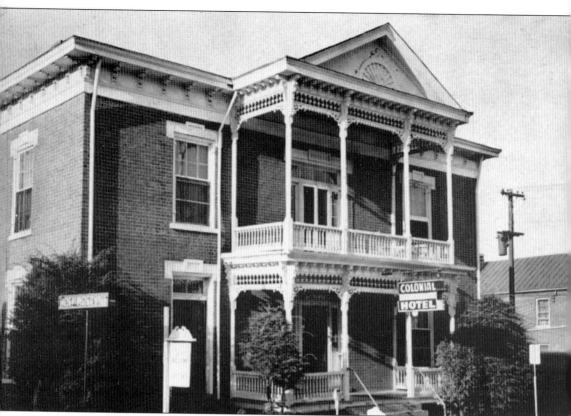

THE COLONIAL HOTEL. This venerable and stately structure stood on the west side of Main Street between Jackson and Roanoke Streets for over 100 years, from 1850 when it was built to 1961 when it was torn down. Much to the dismay of many of the town's citizens it was razed to make room for the new Roses Department Store building, which later became the Grand Piano and Furniture Store in town. Built originally as the Henderson House, it was known by many names and served many functions over its lifespan. It housed the Blacksburg Savings Institution and contained a small private school after the Civil War. It was also called the Giles Thomas House, the Kent House, the Green Hotel, and finally the Colonial Inn. Over the years, children were born in it and according to one source many girls who came to town to attend dances at VPI stayed here. (DLA.)

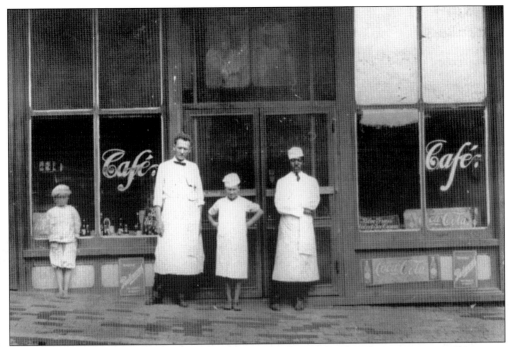

THE BLUE RIBBON CAFÉ. In this photo, three employees (and perhaps a customer!) pose in front of the popular Blue Ribbon Café, also known as Nick the Greek's place. (JC.)

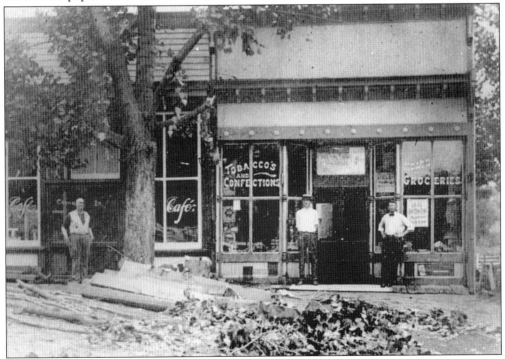

STORM DAMAGE OR CONSTRUCTION. In this photo, these men appear to be surveying some damage to this tree or else the tree is being trimmed for possible removal. These two businesses were just around the corner from Ellett's Drug Store. (DLA.)

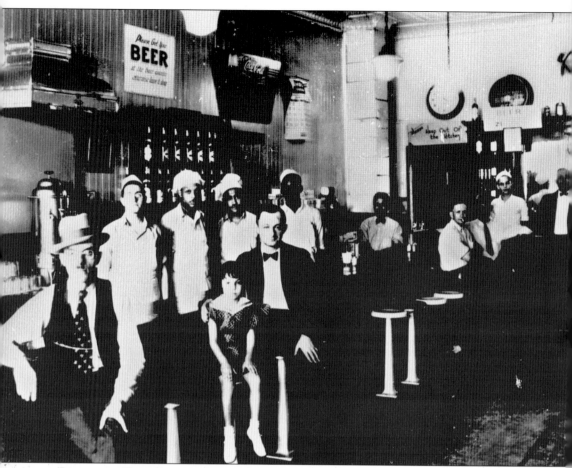

INSIDE THE BLUE RIBBON CAFÉ. This 1936 photo shows us the interior of Nick Kappas' café and restaurant. The building that housed the café was built in the 1890s and a store or restaurant, often called Greeks, has existed on this site since that time. A brick front was added to the building in the 1920s. Mr. Kappas is on the front left of the photo wearing the hat and tie. Mr. Kappas' son Chris has carried on the restaurant tradition in Blacksburg down to the present day. (DLA.)

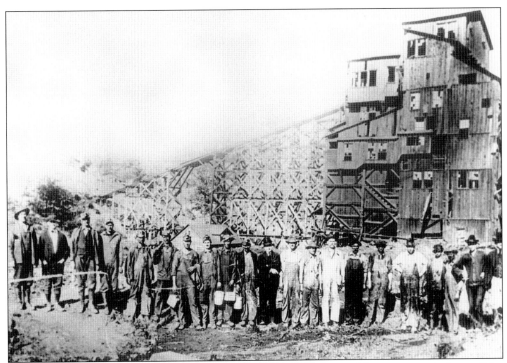

THE MERRIMAC MINES, 1922. Coal miners pose with the owner of the company in front of the coal tipple at the Merrimac mines in Montgomery County, just outside of Blacksburg. The Huckleberry railroad first connected Blacksburg to these mines in 1904. (DLA.)

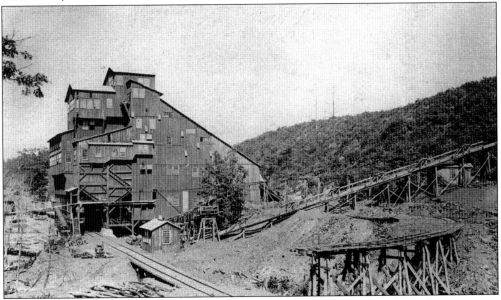

THE COAL TIPPLE. In this undated photo, the Merrimac mines' coal tipple appears to have been abandoned. The coal tipple was the building where the mined coal was graded, washed, and then loaded into railroad cars. The Merrimac miners dug anthracite coal rather than bituminous coal, which was the more common variety of coal found in southwestern Virginia. (DLA.)

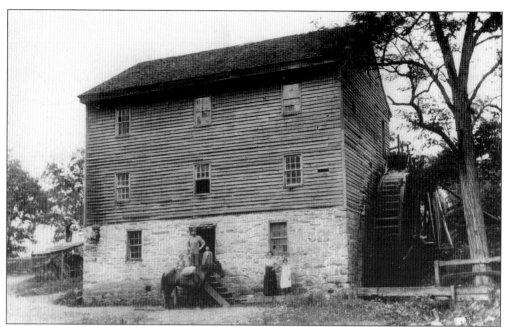

HANCOCK'S MILL, 1900. In 1900, downtown Blacksburg had electricity and several modern buildings. But on the outskirts of town life had not changed so much. In this photo, Montgomery County miller Sam Robertson and his family pose in the doorway of Hancock's Mill, which was on the Old Catawba Road. (DLA.)

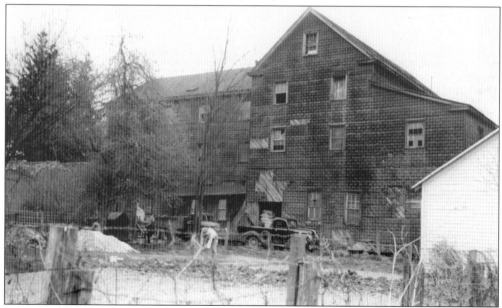

THE OLD MILL BUILDING. This large building was built in the early 20th century for use as the Blacksburg Milling and Supply Company and still stands, though it is hardly recognizable, on the corner of Draper Road and College Avenue. It was later known as Reliance Mills and it sold flour and farm implements. In the 1940s, the building was dramatically altered. Its upper floors were adapted for rental housing and the ground floor became an important part of the commercial life of College Avenue. (JC.)

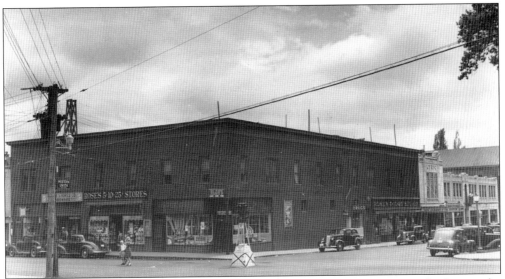

MAIN AND COLLEGE, C. 1940. In 1922, the new Plank and Hoge, or as it was also known the Plank and Whitsett Building, was built on this site. Down College Avenue the Lyric Theater can be seen as well as the top of the mill building. (DLA.)

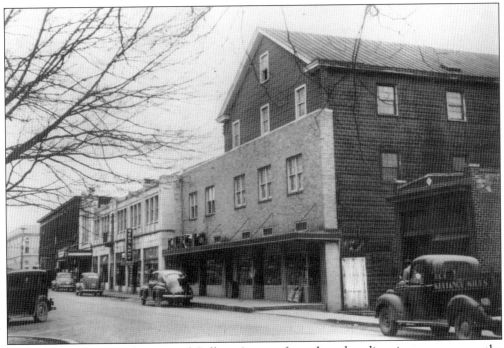

COLLEGE AVENUE. In this view of College Avenue from the other direction, one can see the new front on the Reliance Mills building as well as some of the shops close to the Lyric. (JC.)

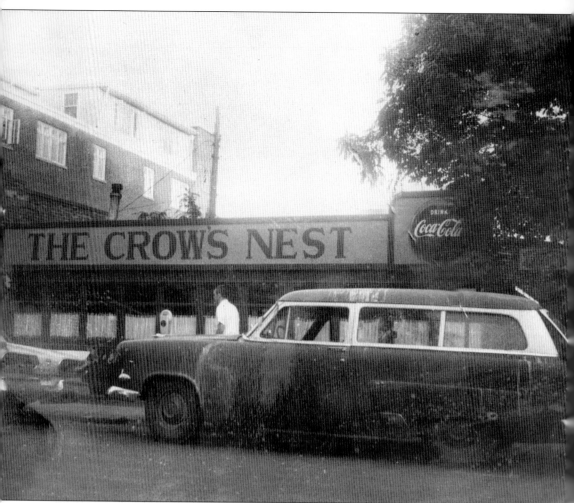

THE CROW'S NEST, C. 1960. The Crow's Nest was a diner located on College Avenue just down the street from the Old Mill Building, which can been seen in this photograph. The Crow's Nest was a popular gathering place for high school students and college students alike. Until the mid-1950s the diner was known as Meredith's. (JC.)

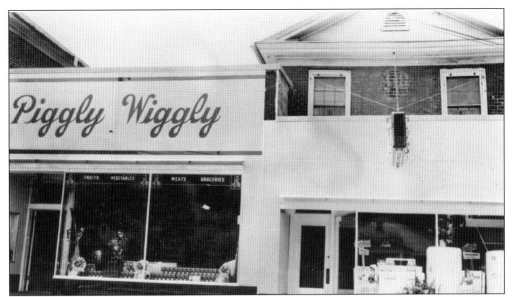

PIGGLY WIGGLY. The Piggly Wiggly was the first successful grocery store chain in the South and there was one on Main Street in Blacksburg by the 1940s. On the right is the Dr. W.B. Conway home and store, which stood on this site from about 1871 until it burned in the 1990s. (JC.)

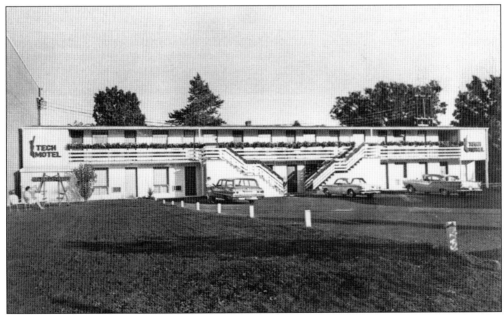

TECH MOTEL. Hardly a replacement for the lovely Colonial Hotel that once sat on Main Street, the Tech Motel did provide a convenient place for visitors to the university to stay. It was built on Draper Road between Roanoke and Jackson Streets and still stands today. It now houses apartments and John Cline's Gentry Photography studio. (JC.)

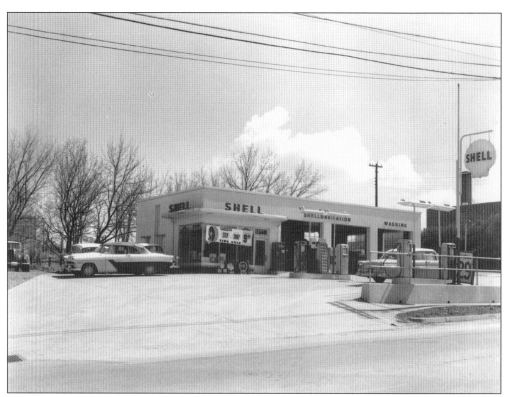

THE SHELL STATION. This photo of Doc Roberts Shell station in downtown Blacksburg was taken on April 4, 1956.

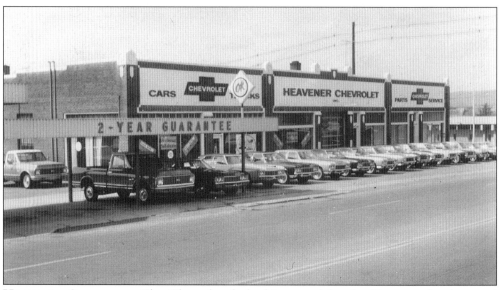

HEAVENER CHEVROLET. The Chevrolet dealership owned by the Heavener brothers and originally named the Blacksburg Motor Company. This is the building where the big fire occurred in 1933 and now is home to Doc Roberts Tire Company.

Seven
HOMES AND CHURCHES

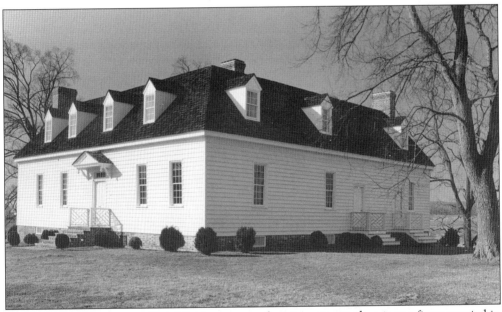

SMITHFIELD PLANTATION. Smithfield was a true frontier outpost when it was first occupied in 1774 by Col. William Preston, his wife, and seven children. Five more of his children would be born in this house in which he lived until his death in 1783. His wife lived in the house for 40 more years until her death in 1823. In 1843, Smithfield became the home of William Preston's grandson, William Ballard Preston, for whom the Preston and Olin Institute in Blacksburg was named. In 1959, Smithfield was donated to the Association for the Preservation of Virginia Antiquities by a direct descendant of Col. William Preston with the provision that the house would be restored and eventually opened to the public. This charge was completed in 1964 and Smithfield is today both a wonderfully preserved example of an 18th-century aristocratic frontier dwelling and also a very popular tourist attraction in Blacksburg. Smithfield gives guided tours of the house and grounds and offers interesting and educational historical programs for adults and children throughout the year. (DLA.)

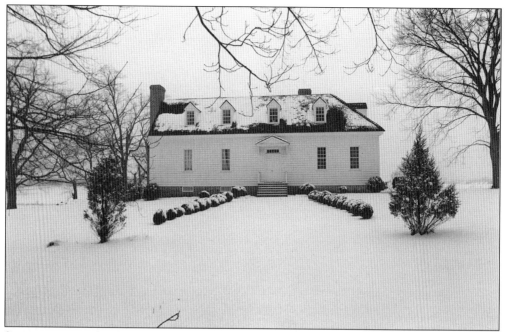

SMITHFIELD IN WINTER. In this lovely photo, Smithfield is covered by a blanket of new fallen snow. This is how Smithfield looks today, fully preserved and restored to its late 18th-century status. (DLA.)

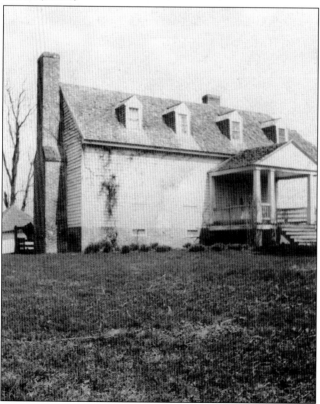

BEFORE RESTORATION. This photograph shows the Smithfield Plantation house as it looked prior to 1959 when the renovation and restoration work on it began. (DLA.)

THE MILLER'S CABIN. This log dwelling, which is located not far from the Smithfield manor, was built in the mid-1850s as a house for the miller. The mill was just on the other side of this house and served the needs of the Smithfield Plantation at that time. Stroubles Creek provided the mill's water. The Miller's Cabin has also been restored.

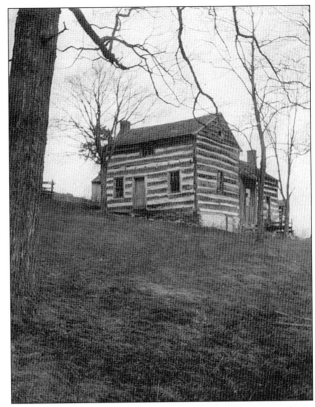

SOLITUDE. This house known as Solitude is now owned by Virginia Tech and is the oldest building on campus. In this 1904 photograph, the landmark is instantly recognizable even though it looks considerably different than it does today. The earliest portion of the house was begun about 1801 though it was altered and enlarged in 1834 and again in 1851.

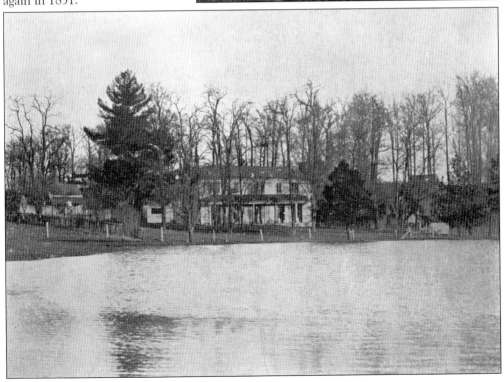

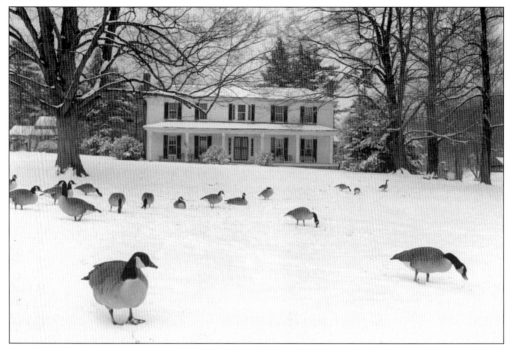

SOLITUDE TODAY. In this more recent photograph, Solitude appears as it looks today, not fully restored but preserved for future generations nevertheless. The house has served many purposes over the years including being the home to professors and university organizations. Solitude was placed on the National Register of Historic Places and on the list of Virginia Historic Landmarks in 1989.

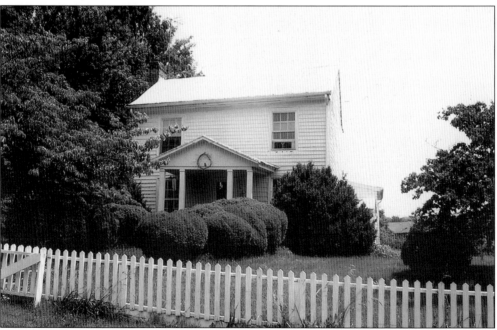

SPOUT SPRING HOUSE. This home, from within the original 16 blocks of the town's boundaries, is a typical two-room, two-story home built in the 1840s. (AP.)

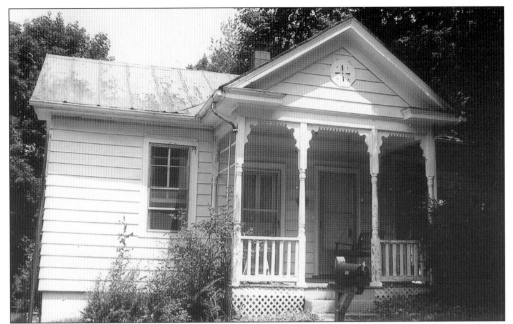

THE MAYES HOUSE. This home is typical of those found in the small African-American neighborhood on Lee Street known as "Bitter Hill," which grew up in the decades following the Civil War. This house was lived in by Dora Mayes, who was a midwife. (AP.)

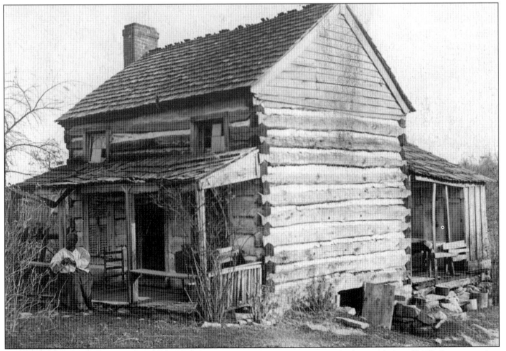

AUNT NELLIE. This is a photograph of Aunt Nellie sitting outside her cabin off of what is today Nellie's Cave Road. Both the road and the cave are named after her. This area, considerably southeast of the town's original boundaries, was also a small African-American enclave. Some descendants of Aunt Nellie continue to live in the neighborhood today. (JC.)

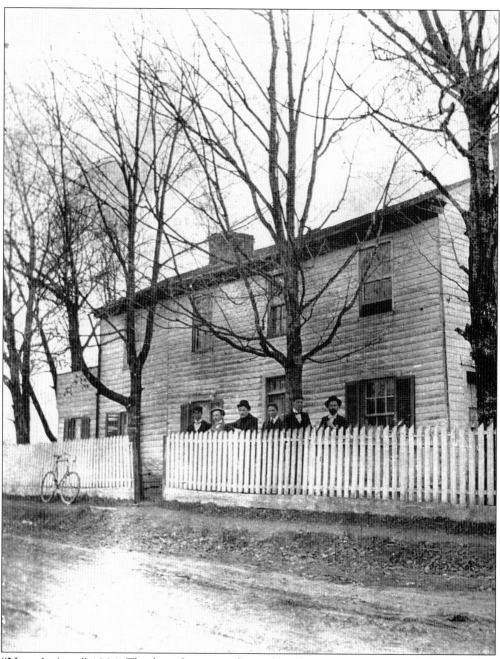

"Noah's Ark," 1904. This large house was located on the VPI campus and provided housing for cadets. The caption on the rear of the original photograph reads, "What a place to call home sweet home." Then as now, bicycles provided a cheap and efficient way to get around the campus and town. (DLA.)

PRICE HOUSE. Nearly hidden by trees at the present time, the Price House is one of the oldest dwellings still standing in the town's historic district. Built in the 1840s in the two-story, two-room style, it originally had a porch which has been removed. The house is now owned by the town and serves as a nature center. (AP.)

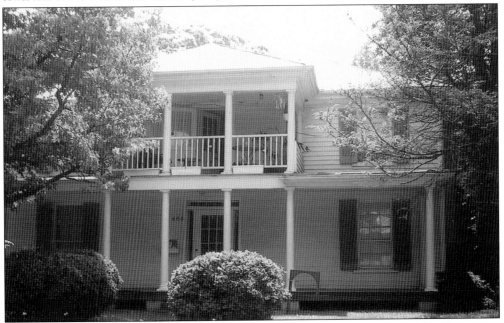

MARTIN-RICHARDSON HOUSE. On the corner of Wharton and Roanoke Streets in Blacksburg's historic district, sits this wonderful two-story home built in the third quarter of the 19th century. As is the case with many older frame structures, the house you see here actually encloses the older original log house. (AP.)

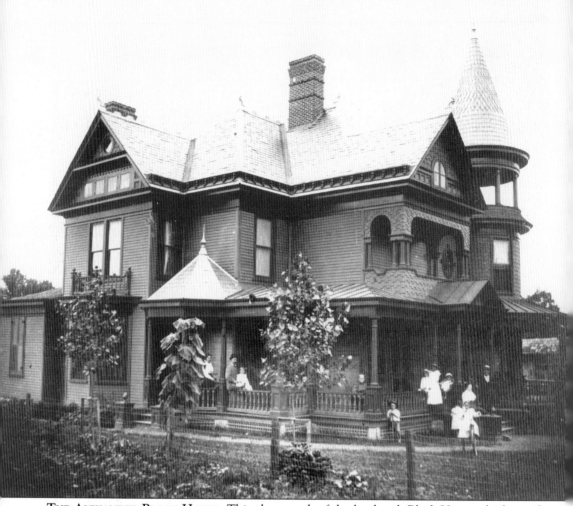

THE ALEXANDER BLACK HOUSE. This photograph of the landmark Black House which stood on Main Street for 100 years was taken around 1910. This was the second Black house on this site, this one being completed in 1892. The house is an exquisite example of Victorian and Queen Anne architecture with its roof slates, stained glass windows, multi-colored paint scheme, turret, and wrap around porch. The house's predominant color scheme when it was built was dark green. (DLA.)

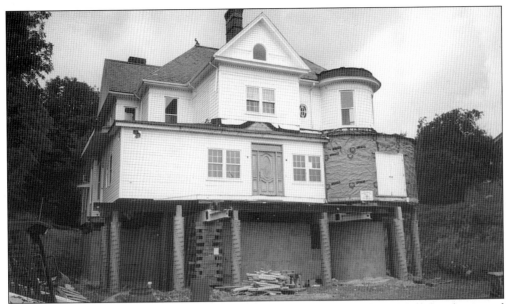

THE BLACK HOUSE MOVED. In 2002, the Black House—which had been owned and operated as a funeral home for several decades—was moved to a location on Draper Road to make way for a new commercial development on Main Street. Even though the house's intricate architectural features were destroyed and altered over the years, plans call for it to be fully restored and to be the home of a Blacksburg historical museum. (AP.)

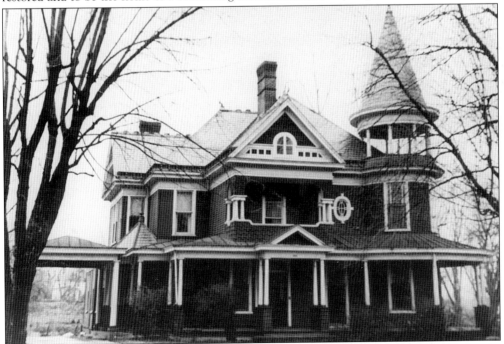

THE BLACK HOUSE, C. 1930. Alexander Black, a descendant of Blacksburg founding family, built his first house on this site in 1850 but it burned down and was replaced by this house. This photo from the 1930s shows a timely addition to the house—a covered portico to accommodate an automobile. (JC.)

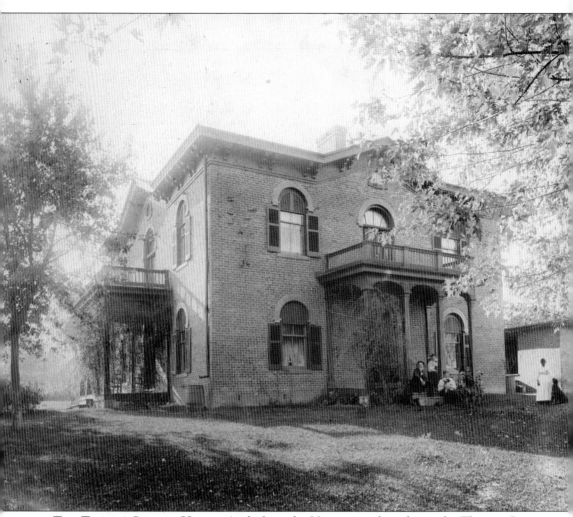

THE THOMAS-CONNER HOUSE. Aside from the Victorian color scheme the Thomas-Conner House appears today much as it did in this photo from around 1900. This house was built on Water (Draper Road) Street in the late 19th century for a professor at the university. The small building to the right of the main house in this photo is the spring house. According to one long time Blacksburg resident, lovely watercress grew in the spring and it was a favorite pastime to linger there and pick it. As is evidenced in this photo, people loved to pose in front of their homes. The Conner House, as it is known today, is owed by Virginia Tech. (JC.)

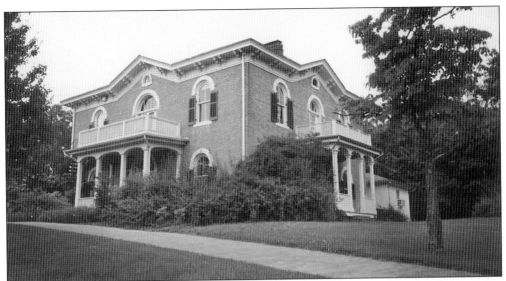

AS IT LOOKS TODAY. In this contemporary photo, the Conner House looks nearly identical to the way it did in the previous photo. In this photo, the Black House can be seen in its new setting beside the Conner House. These two magnificent Victorian homes look out upon the town from their perches on Draper Road. (AP.)

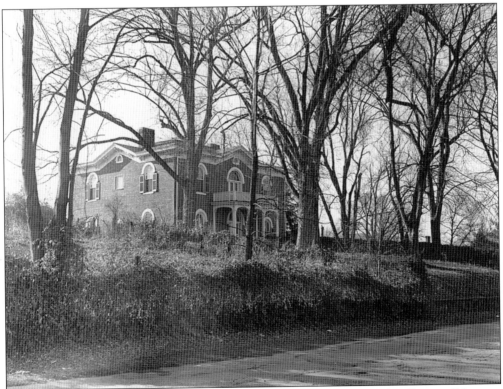

CONNER HOUSE, 1954. In this photo of the Conner House, the original wall can still be seen along the street. When the house was newly built the property was surrounded, as were so many in Blacksburg, with a white fence. (DLA.)

THE "OLD PALMER'S GATE." This early photograph shows the original gate which led up to the Amiss-Palmer mansion, better known as Mountain View. This tree-lined lane fronted on South Main Street. The driveway is still tree-lined though the trees are much bigger now and it still leads up to the magnificent home. The wall and the gates are gone though. The estate or plantation which surrounded the house was of antebellum origin and occupied a very large land area to the southeast of the original town boundaries. In the 1920s, the property began to be subdivided into home lots though some of the land retains its rural character to today. (DLA.)

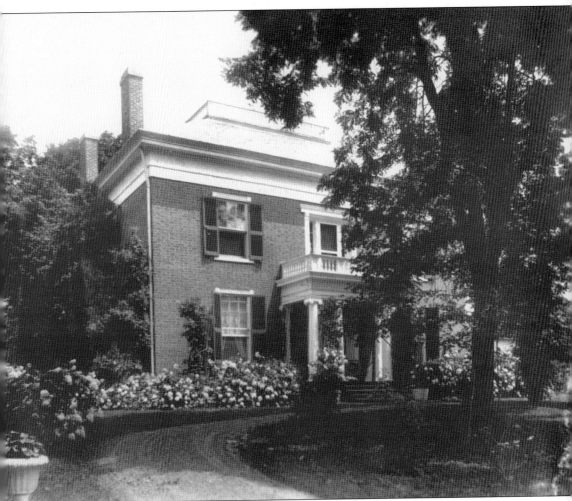

MOUNTAIN VIEW. This splendid example of Greek revival architecture is the Amiss-Palmer mansion which sits on a knoll between Eheart and Eakin Streets. Mountain View can be seen in several of the panoramic views in this book surrounded by white fencing and sitting above the historic town boundaries to the southeast. The house was built about 1856 by successful merchant Edwin J. Amiss who owned several businesses in town. The estate was a fully functional plantation that also included extraordinary flower gardens and grape arbors near the house. On the property today, in addition to the house, are two log outbuildings, one of which may have been slaves' quarters, the other was a smokehouse. A detached brick kitchen, typical of the time the home was built, also survives. Mountain View is to this day a private residence. It was restored by and is currently lived in by Mr. and Mrs. Robert Cranwell. (DLA.)

CROY HOUSE. In an architectural study done of the historic homes in Blacksburg for the town's bicentennial in 1998, this home was identified as being possibly the oldest still standing within the original 16-block town boundaries. It would be impossible though to tell this from the outside since, like so many other structures from the antebellum period this frame house was simply built around the original log house which is now hidden from view. (AP.)

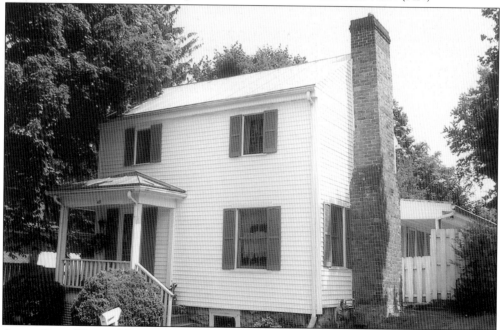

ADAM CROY HOUSE. This is another of the earliest homes in the original town that remains today. Again the original house, built in the 1840s, was a one room log structure that has been hidden by later construction. (AP.)

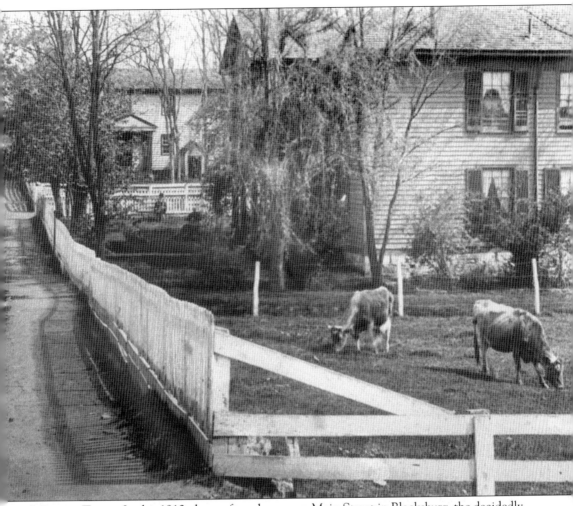

A RURAL TOWN. In this 1912 photo of two homes on Main Street in Blacksburg, the decidedly rural flavor and character of the town is quite evident. Big homes, white picket fences, and open spaces characterized Main Street and all of Blacksburg at this time. The house in this photograph is possibly that of Dr. Harvey Black which was built on Main Street in the 1850s. While cows are no longer present on Main Street and while there are very few residences in the downtown area today, the rural flavor of the town persists to some degree even in the face of extraordinarily rapid change in the past decade. Virginia Tech's farms with their cows, sheep, and horses are on many residents way as they travel to and from work, and in the southeastern part of town lay Hoge's Pasture, a large tract of farm land that has been left to the town to remain undeveloped in perpetuity. (DLA.)

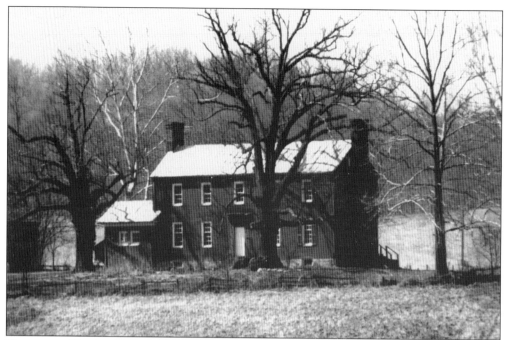

KENTLAND HOUSE. This 19th-century home was built by Maj. James Kent on a fine piece of bottom land along the New River near Blacksburg. Kentland Farms is now owned by Virginia Tech and is used as an agricultural research station. (DLA.)

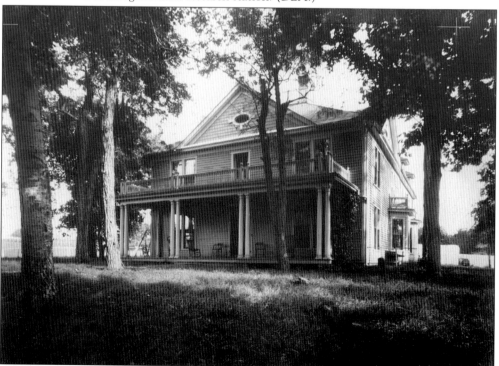

CAMPBELL HOUSE. This house, at one time used as an infirmary, was also the residence of the Hoge family, prominent business and property owners in Blacksburg. (DLA.)

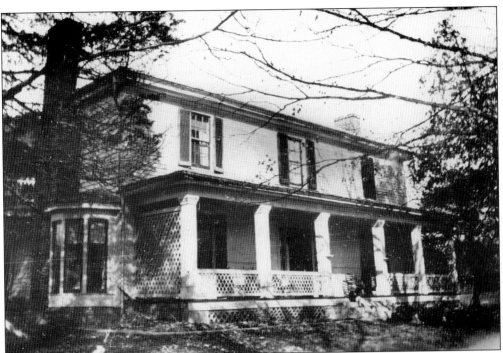

CLIFFSIDE. This imposing 19th-century house, known as Cliffside, was in the Ellett section of Montgomery County near the town of Blacksburg. The earliest approaches to Blacksburg came through Ellett Valley from the northeast and the area remains a favorite of townspeople today. (DLA.)

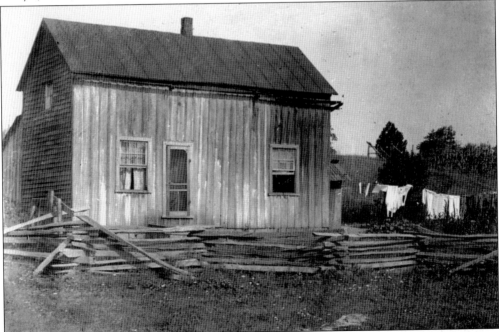

THE PREACHER'S HOUSE. This is the modest home of Reverend Stallings, the minister at Blacksburg's St. Michael's Lutheran Church. This photograph was taken in 1912. (DLA.)

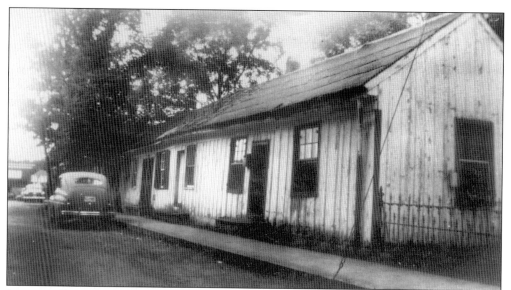

LYBROOK ROW. Built around 1870 by W.M. Lybrook, this was Blacksburg's first cheap, off-campus housing for young men attending the new Virginia Agricultural and Mechanical College. It was derisively referred to as "Hell's Row," and apparently carried a bad reputation throughout its existence. It was located on Church Street between Roanoke and Jackson Streets. In this photo, the old town hall can be seen at the end of the street. (JC.)

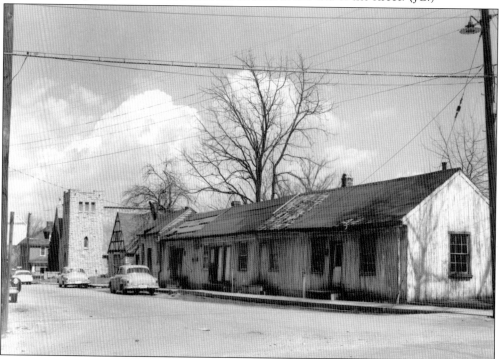

LYBROOK ROW, 1956. In this later photo of Lybrook Row, the building looks completely dilapidated and ready to be demolished. The Lybrook house has already been torn down in this photo to make way for the new addition to the Episcopal church located at the end of the block. (DLA.)

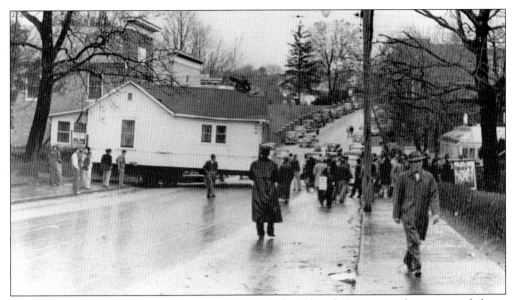

MOVING A HOUSE. The St. Mary's Roman Catholic Church Rectory is being moved down Main Street in this photo from 1945. On the right in the photo, one can see a Navy recruiting poster outside the downtown post office building and just beyond it the old street car diner that sat for a few years on the opposite corner. (DLA.)

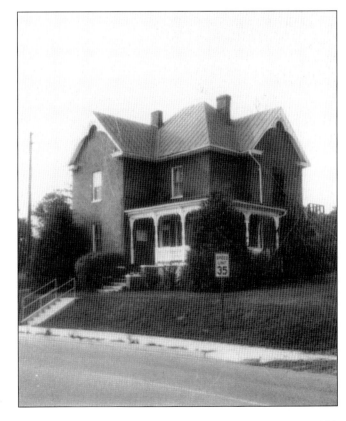

NORTH MAIN STREET HOUSE. There are very few buildings from the late 19th century that survive on the northern end of Main Street past College Avenue in the downtown area. This house which dates from this period has been altered greatly from how it appears here and has been incorporated into the larger Bogan's Restaurant building. (JC.)

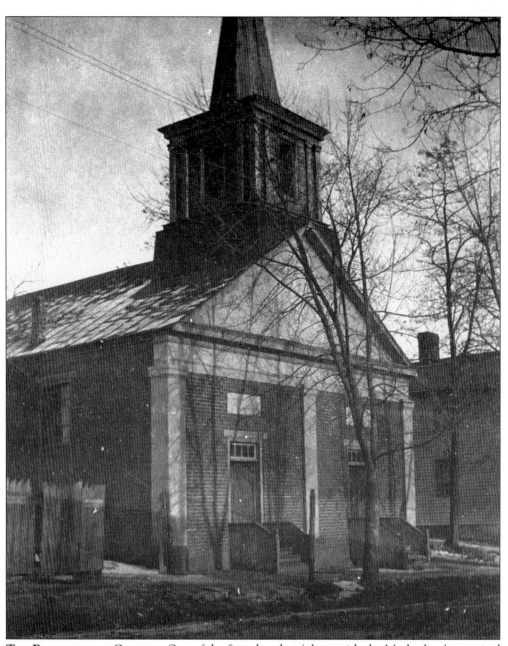

THE PRESBYTERIAN CHURCH. One of the first churches (along with the Methodists) organized in Blacksburg was the Presbyterian, established here in 1832 with 12 members. In 1847, the congregation built this church at 117 South Main Street and it is today the oldest building on Main Street and one of the oldest in town. Slave labor was reputedly used in its construction. It was used as a church until 1904 when the Presbyterians moved into a new church close by on Roanoke Street. This church, which is also still standing, features beautiful Tiffany stained glass windows. The steeple on the Presbyterian Church was removed in 1913. Since 1904, this building has served a variety of groups and organizations, most notably the Independent Order of the Odd Fellows. At present and in the recent past it has been home to a series of restaurants. (DLA.)

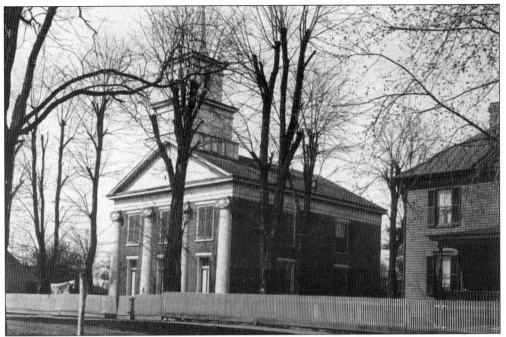

BLACKSBURG METHODIST CHURCH. This grand church building built in 1846 was actually the third Methodist church in Blacksburg. The Blacksburg Methodist Society was founded fully 15 years before the town of Blacksburg was actually laid out. Until 1840, the Methodists met in log structures when construction on this church began. In 1906, this building was torn down and replaced by the Whisner Memorial Methodist Church, which still stands. (DLA.)

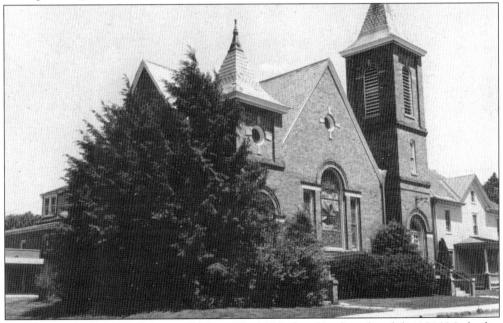

WHISNER MEMORIAL METHODIST CHURCH. In 1906, this church replaced the 1846 Methodist Church and was built in the same location on Church Street. It still stands though it has been incorporated into an even larger complex and serves today as the church's fellowship hall.

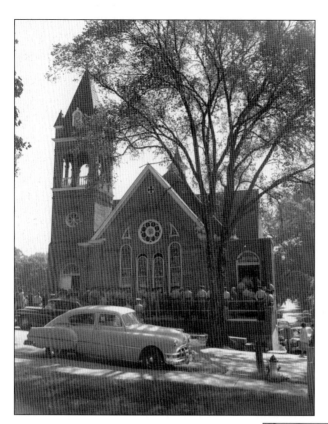

BLACKSBURG BAPTIST CHURCH. The original Baptist Church in town was on the corner of Roanoke and Church Streets but was moved in the early 20th century when this beautiful church was built on the corner of Roanoke Street and Draper Road. Shown in this photo from around 1950 is "church call" for VPI cadets who are lined up and waiting to enter on a Sunday morning. This church burned tragically in December 1958 and was replaced by a larger, modern church building on North Main Street where it continues to serve the large Baptist population of Blacksburg today.

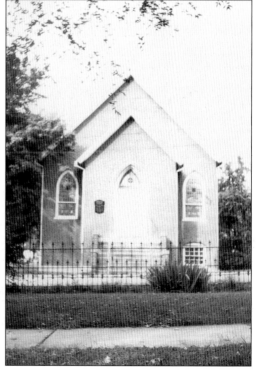

BLACKSBURG CHRISTIAN CHURCH. This is the Blacksburg Christian Church in its first location at the corner of Church and Roanoke Streets. This church was built about 1900 on the foundation of the much older Baptist Church. To accommodate a growing congregation the Christian Church moved later to a larger building in the northwest part of town. This fine old building still stands and is now the town's Jewish Center. (Photo courtesy of the Christian Church.)

ST. MARY'S CATHOLIC CHURCH. This is the original Catholic church in Blacksburg located just off Progress Street on Wilson Avenue. It was used until a new stone church was built just opposite it on the corner though eventually the Roman Catholic population outgrew this building as well. A third church was built on Harding Avenue and a fourth church is now underway off Price's Fork Road to accommodate Blacksburg largest individual church congregation.

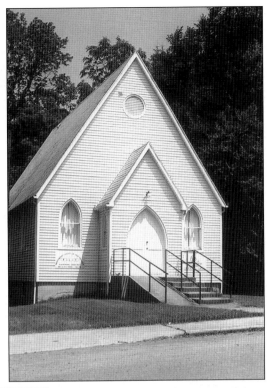

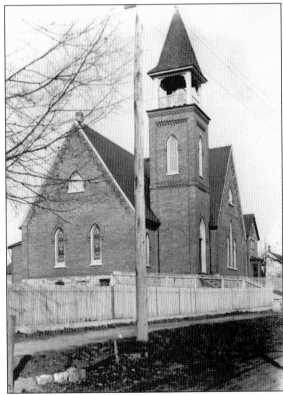

LUTHER MEMORIAL LUTHERAN CHURCH. The first Lutheran congregation in Blacksburg was organized in the 1750s but this church was not built until 1883. It stood off North Main Street on what is today Turner Street. The current Lutheran Church on the corner of Price's Fork Road and Tom's Creek Road contains these stained glass windows, some of the church's interior furnishings, and bricks from the original church as well. (DLA.)

CHRISTMAS 1923. This is an interior view of the 1883 Lutheran Church on Turner Street. Attendance spiked at the Lutheran church during the Christmas season largely because of the popularity of the decorated Christmas trees, a German tradition that adorned the church's sanctuary. (DLA.)

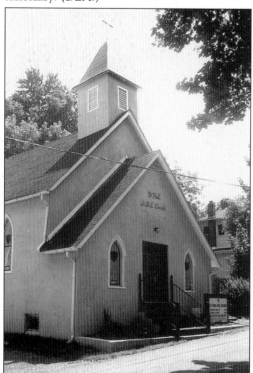

THE AME CHURCH. In 1893, three members of Blacksburg's African-American community, George Washington, Spencer Johnson, and John D. Smith, purchased land on Penn Street for a church building. This church, which still stands today, was completed in 1901. (AP.)

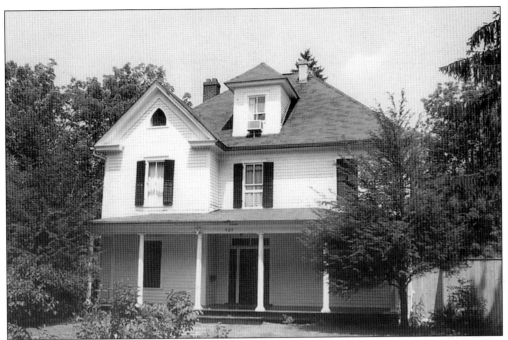

THE ELLETT HOUSE. This fine home from the early 20th century still stands within the boundaries of the town's original historic district—in an area dominated today by student rental housing.

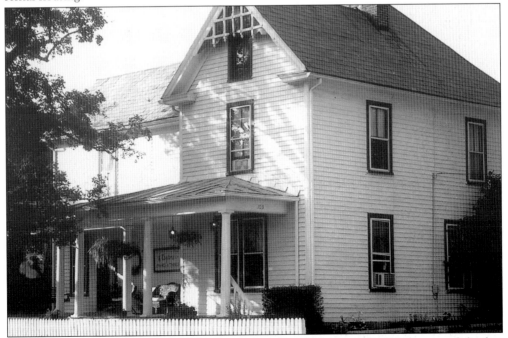

THE BENNETT-PUGH HOUSE. This house, which was built around 1900, is one of the last houses to survive on Main Street in the downtown area. It is a contemporary reminder of the open spaces and many inviting residences that once lined the street in the 19th and on into the 20th century. It has been the home of Taylor's Frames and Things for many years. (AP.)

MILLER-SOUTHSIDE. As Blacksburg's population grew, neighborhoods began to expand beyond the traditional boundaries of the town. In the 1920s and 1930s, a new affluent neighborhood evolved in the area to the south and west of the original town center. The Miller-Southside neighborhood is still today a part of town characterized by many historically significant and picturesque homes that line Draper Road and Preston Avenue. (DLA.)

ABOUT THE AUTHOR

Richard Alan Straw is Professor of History at Radford University where he has taught courses in American, Appalachian, and Southern History since 1981. He has lived in the New River Valley for 22 years, 13 of them in Blacksburg. Primarily a cultural historian, Dr. Straw has written on food, music, photography, and coal mining. He is co-editor of the forthcoming book, *High Mountains Rising: Appalachian History and Culture* from the University of Illinois Press. Dr. Straw is married and has three children.